D1626815

THE
HOLLYWOOD
BOOK CLUB

═══ READING WITH THE STARS ═══

BY STEVEN REA

CHRONICLE BOOKS
SAN FRANCISCO

Library of Congress Cataloging-in-Publication Data:

Names: Rea, Steven, author.
 Title: The Hollywood book club : reading with the stars / by Steven Rea.
 Description: San Francisco : Chronicle Books, [2019]
 Identifiers: LCCN 2018053807 | ISBN 9781452176895 (hardcover : alk. paper)
 Subjects: LCSH: Motion picture actors and actresses—Books and
 reading—California—Los Angeles. | Celebrities—Books and
 reading—California—Los Angeles. | Books and reading—California—Los Angeles.
 Classification: LCC PN1993.5.U65 R425 2019 | DDC 791.4302/8092279494—dc23 LC re
available at https://lccn.loc.gov/2018053807

Manufactured in China

MIX
Paper from responsible sources
FSC™ C136333
www.fsc.org

AP Photo: 36; Getty Images/Archive Photos: front cover, 32; Getty Images/Bettmann: 30, 66, 68; Getty Images/Ed Clark/LIFE Picture Collection: 52; Getty Images/Hulton Archive: 18, 34; Getty Images/John Kobal Foundation: 25; Getty Images/Popperfoto: 40; Globe Photos/Frank Bez: 44; Magnum Photos/Dennis Stock: 10; MPTV Images: 16; MPTV Images/Bernie Abramson: 15; MPTV Images/Sid Avery: 102; MPTV Images/Gunther: 50; MPTV Images/Mark Shaw: 43; MPTV Images/Universal Pictures: back cover left, 109; MPTV Images/Warner Bros.: 60; Photofest/American International Pictures: 105; Photofest/Clarence S. Bull/MGM: 12; Photofest/Christie/Columbia Pictures: 64; Photofest/Columbia Pictures: 26, 94; Photofest/Cronenweth/Columbia Pictures: 20; Photofest/J. Arthur Rank Organization: 59; Photofest/Bert Longworth/Warner Bros.: back cover center, 56; Photofest/MGM: back cover right, 28, 49, 63, 81, 82, 90, 110, 113, 117; Photofest/Paramount Pictures: 9, 46, 82, 86, 92, 114; Photofest/RKO Radio Pictures: 78, 89; Photofest/Scotty Welbourne/Warner Bros.: 38; Photofest/Bert Six/Vitaphone/Warner Bros.: 100; Photofest/Twentieth Century Fox: 22, 55, 76, 97, 98; Photofest/United Artists: 74; Photofest/Warner Bros.: 70, 72, 107

Design by Michael Morris.

10 9 8 7 6 5 4 3 2 1

Chronicle Books LLC
680 Second Street
San Francisco, California 94107
www.chroniclebooks.com

"Read any good books lately?"
—**HUMPHREY BOGART,** *In a Lonely Place*

CONTENTS

INTRODUCTION

POP QUIZ: What's the name of the bookshop where Audrey Hepburn is employed in *Funny Face*?

(a) Acme Book Shop
(b) Argosy Book Store
(c) Embryo Concepts
(d) Flourish and Blotts
(e) The Shop Around the Corner

Cheers if you answered "c." Hepburn's empathicalism-spouting gamine is a clerk at this philosophy books emporium in '50s boho Greenwich Village—her hushed, dusty, musty world rudely upended when Fred Astaire and a bossy team from a fashion mag charge in with cameras and model in tow. And extra points if you can match the other four fictional establishments with the films they're in. (Answers below)

Books and movies have been intersecting in significant ways since the silent era: actors on screen reading tomes that tell us something about the characters they're playing; books as instructional guides, or plot devices, or humorous props; or as stealth

objects slipped into bookcases, pages carved out, to hide a weapon or a wad of cash. (And what about the bookcases with secret hinges—entryways to hidden lairs?) From Voltaire and Emile Zola to Shakespeare and Kerouac to Sylvia Plath and David Foster Wallace, biopics of authors and poets have made for one of filmdom's most reliable genres. The life stories of fictional scribes, too, have always been a big part of the big screen diet. *Barton Fink*, anyone?

Novels and biographies, history and investigative series, memoirs and sci-fi—thousands upon thousands of published works have provided the foundation, the core, the starting-off-point-but-we're-going-to-totally-change-the-ending-and-make-you-really-mad basis for motion picture adaptations.

The Hollywood Book Club is a bibliophile-meets-cinephile celebration of the convergence points between these two very different media. Its 55 photographs capture some iconic stars with some pretty iconic (or ironic) books in their mitts. James Dean, Marilyn Monroe, Sophia Loren, Bette Davis, Sammy Davis Jr., Humphrey Bogart, and Lauren Bacall, they're all here with literature (or not) in their hands—or on their laps, or in the general vicinity. Some of the titles are easily discernible in these images—the book jackets or spines held upright for the photographer's lens, for our view. But some photos required further investigation. That gorgeous shot of a napping Leslie Caron (see p. 28) seated with the book open to a page of print? By enlarging the image and isolating the book, phrases became readable: "the food which we produced . . . the

softness of the bed . . . coffin walls . . . " Enter them in an internet search engine and William Faulkner's *Absalom, Absalom!* shows up like magic: Modern Library 1951 edition, p. 160. Ditto for the volume resting on Orson Welles's chest (p. 36): the just-moved-to-L.A. writer, director, actor, and soon-to-be-filmmaker was well into *A History of Technology, Vol. III: From the Renaissance to the Industrial Revolution.* A little light reading before bed.

These candid pics, publicity shots, and production stills—many taken by the respective Hollywood studios' mostly unsung and intrepid still photographers—are sequenced in six thematic categories: There's a batch of "ex libris," at-home images of the stars lounging in their personal libraries, or in a garden on a rustic twig settee (see Edward G. Robinson, p. 38). There's a collection of stars reading kid-lit to their kids. There's an often surprising, amusing, illuminating series taken on set (a bare-shouldered Joan Collins hefting Thomas Wolfe, see p. 54, or Dennis Hopper reading Stanislavsky, see p. 60). There are two in-a-bookstore or some-place-with-a-pile-of-books portraits. There is a batch of produc-tion stills—shots taken with the actors and actresses in character, in costume, in the movie. And, finally, a group of "source material" images: Steve McQueen with *The Great Escape* (p. 102), Gregory Peck with a copy of *To Kill a Mockingbird* (p. 108), Jane Wyman with *The Yearling* (p. 110). The stars of the film interpretations going back to the original works—and doing a little crossover pro-motion while they're at it.

The books in *The Hollywood Book Club* make for some eclectic reading: Irving Stone and Oscar Wilde, a sex manual and a Louis Armstrong memoir, Walt Disney and Ernest Hemingway.

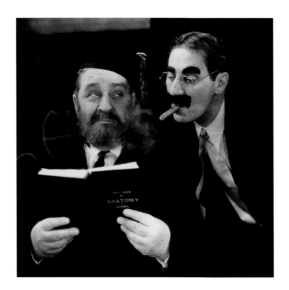

Groucho Marx famously quipped that he didn't want to belong to any club that would accept him as a member. But it's hard to imagine that he wouldn't have wanted to belong to the Hollywood Book Club (in fact, Marx was an avid admirer of the book in Joanne Woodward's hands on p. 22). The fast-talkin', cigar-flickin', mustachioed Marx Brother is also credited with another old saw, one that speaks to the immeasurable satisfaction of spending time with a bound volume of prose or poetry: "Outside of a dog, a book is man's best friend. Inside of a dog, it's too dark to read."

Enjoy!

ANSWERS: (a) *The Big Sleep*, (b) *Vertigo*, (c) *Funny Face*, (d) *Harry Potter and the Sorcerer's Stone*, (e) *You've Got Mail*

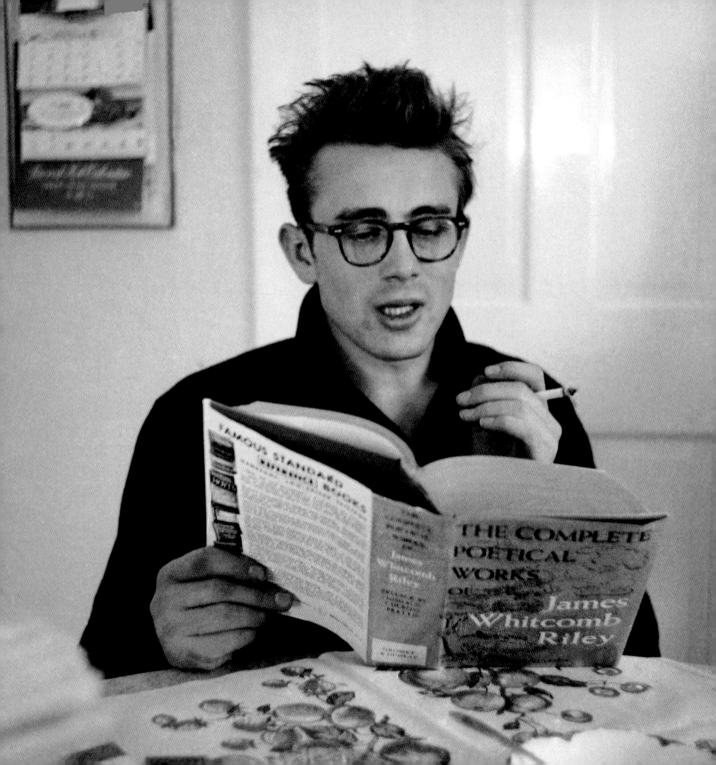

The Hollywood icon of *East of Eden*, *Rebel Without a Cause*, and *Giant*, seated at his aunt and uncle's breakfast table in Fairmount, Indiana, with a cigarette and *The Complete Poetical Works of James Whitcomb Riley*. The Indiana poet was known for his humor, folksy vernacular, and children's verse. **JAMES DEAN**, a fellow Hoosier, lived on his relatives' farm from the age of nine on. This Dennis Stock photograph was taken in February 1955. Dean died, in a car crash, at the end of September that same year. He could be reading Riley's "The Days Gone By."

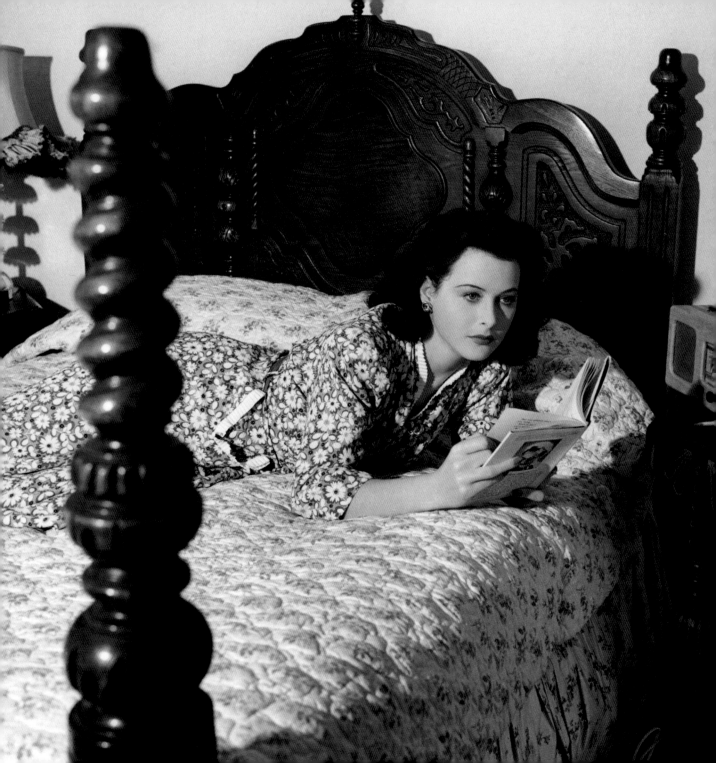

HEDY LAMARR, the subject of three biographies, a documentary, and a graphic novel about her patented invention of the frequency-hopping spread spectrum, was one of the biggest screen stars of the 1940s and early '50s. The Austrian-born beauty was signed to MGM, and there's a pair of the studio's scripts on the bottom shelf of her nightstand.

For his reading pleasure, **SAMMY DAVIS JR.** lounges with a paperback edition of Lloyd C. Douglas's mega-selling biblical epic *The Robe*, originally published in 1942. The film version, starring Richard Burton and Jean Simmons, was released in 1953 in CinemaScope—the first film to be issued in the widescreen format. Davis starred in *Anna Lucasta* in 1958, *Porgy and Bess* in 1959, and then joined Frank Sinatra, Dean Martin, and his Rat Pack pals in *Ocean's 11* in 1960.

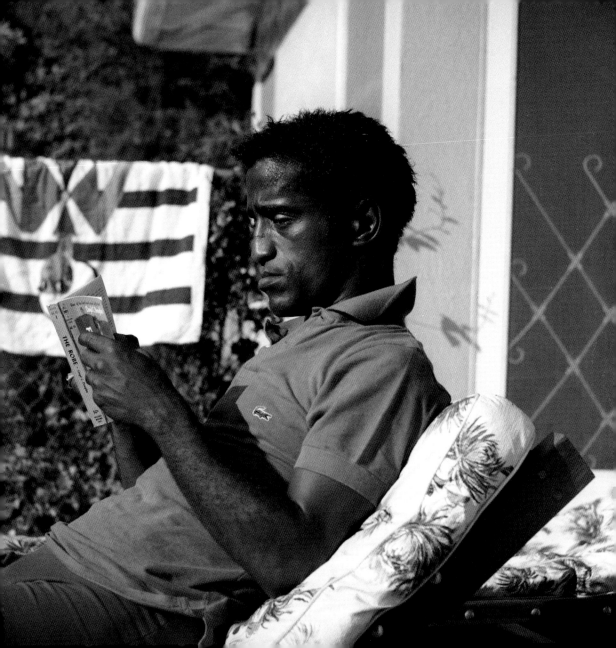

At the home she shares with Humphrey Bogart, the *To Have and Have Not* and *Big Sleep* siren **LAUREN BACALL** rifles through a pictorial history of twentieth century conflict, open to "The March of Aggression" chapter. Robert Capa's iconic "The Falling Soldier" is among the spread of combat images visible. The other book next to Bacall in this 1946 photo? William Chaffers's essential *Marks and Monograms on Pottery and Porcelain.*

In early 1962 it was announced that Ian Fleming's espionage best seller *Dr. No* was about to be filmed—with a Scotsman, **SEAN CONNERY**, as the British spy James Bond. A London photographer was quickly dispatched to the actor's Hampstead flat in London to capture the soon-to-be licensed-to-kill secret agent. Here Connery lounges on his sofa immersed in a book—maybe one of Fleming's? On the window sill, Mr. 007's other titles include: *Lilith* by George MacDonald, *Marianne* by Frederic Mullally (also known as *Danse Macabre*), and *The Complete Works of Shakespeare*.

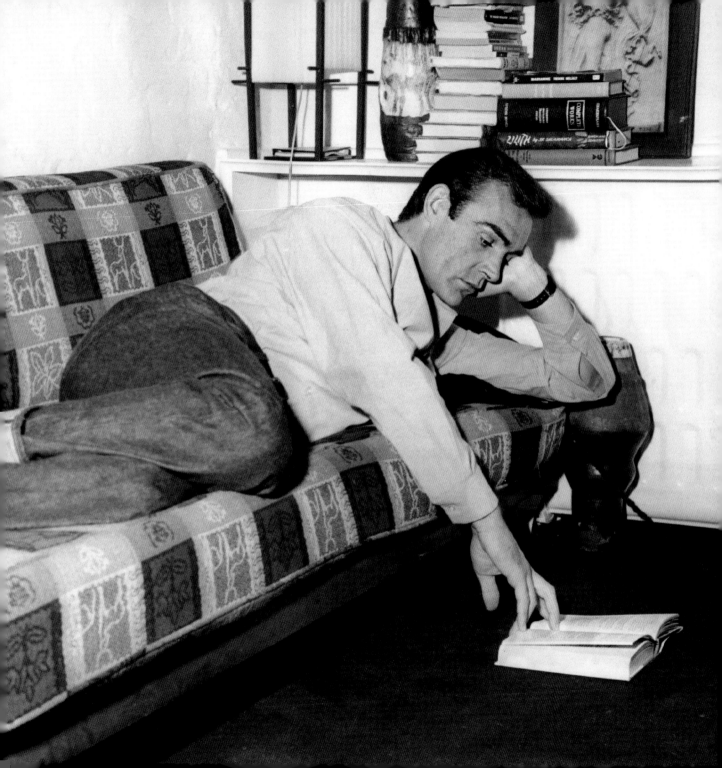

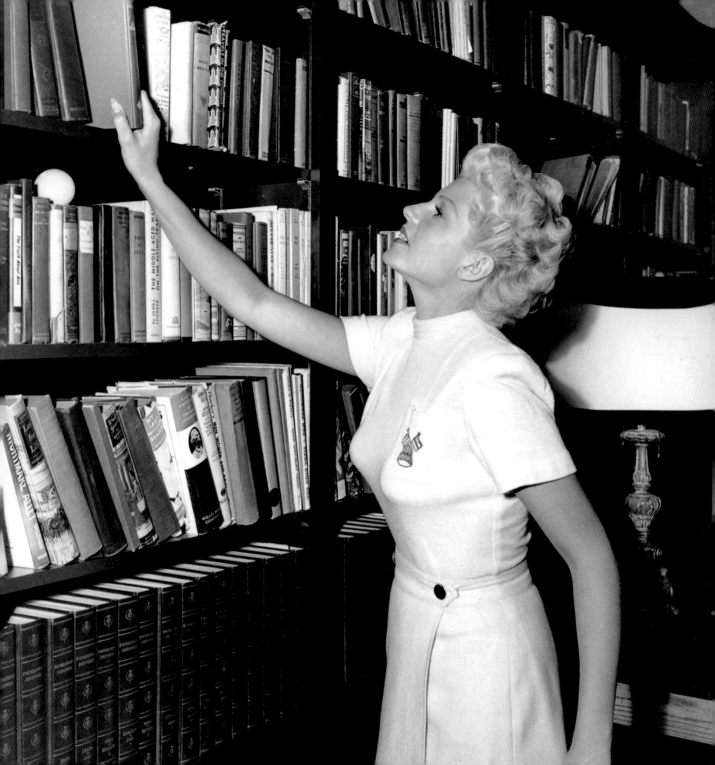

Still sporting the platinum hairdo Orson Welles insisted she have for 1947's *The Lady from Shanghai*, **RITA HAYWORTH** scans her library for a good read, pulling a title adjacent to Dickens's *A Christmas Carol*. Also visible in Hayworth's collection: *Basic Writings of Thomas Jefferson, Nightmare Alley* by William Lindsay Gresham, and *Progress and Poverty* by Henry George.

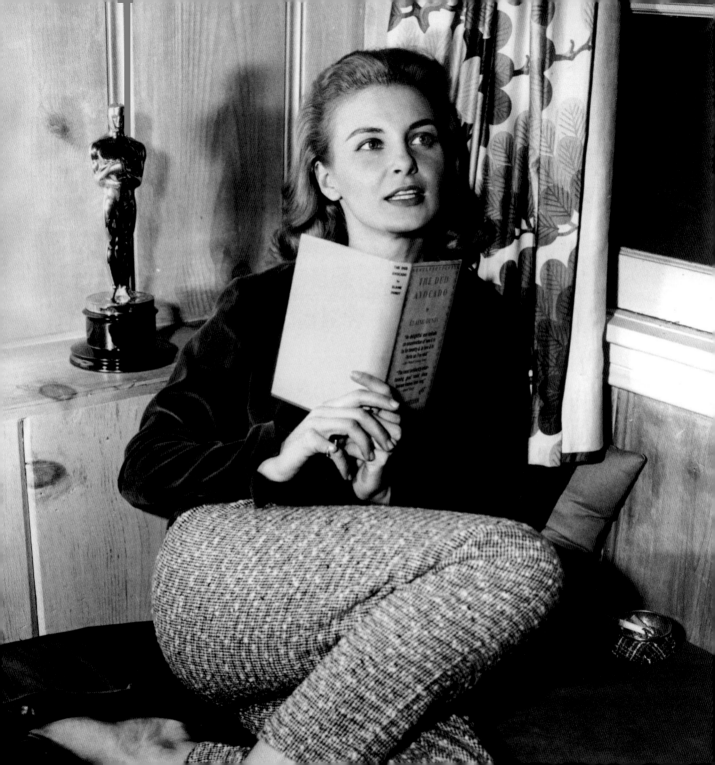

Curled up with a good book and a good Oscar—the one she won in 1958 for Best Actress in *The Three Faces of Eve*—**JOANNE WOODWARD** is well into *The Dud Avocado*, Elaine Dundy's debut novel, published that same year, about a young American on the loose in Paris. The book was an instant bestseller, oft-reissued in the decades since, and counts Groucho Marx and, more recently, Greta Gerwig among its fans.

BUSTER KEATON, the silent screen funnyman-turned-talkies-star-turned-sad-eyed character actor, spent $300,000 in 1926 ($4.3 million today) to build his Italian villa–inspired home in Beverly Hills. It was a place to sit by the fire with a compelling read, and to shoot his first talkie there, too: 1931's *Parlor, Bedroom and Bath*. Cary Grant and James Mason would each later own and occupy Keaton's manse—not certain if it came with Keaton's library collection.

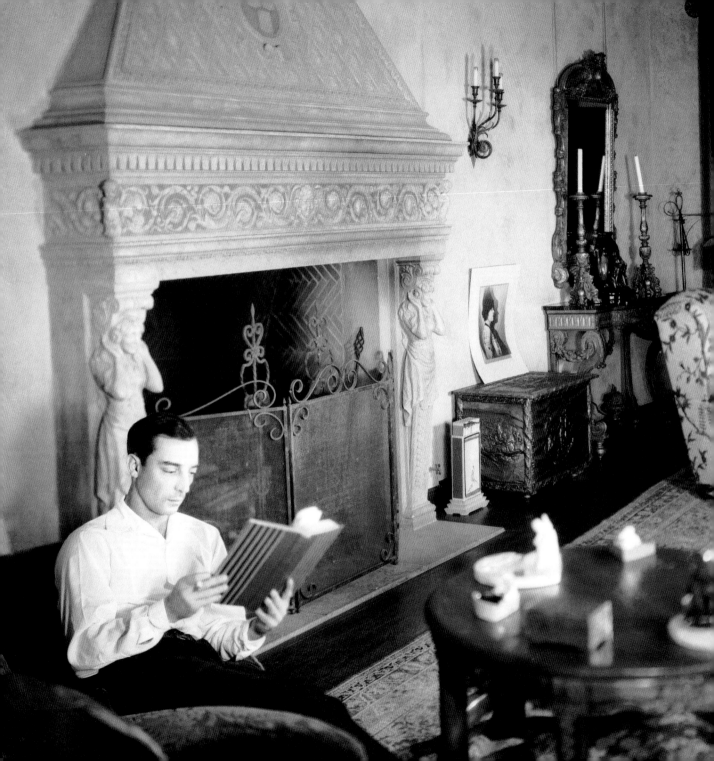

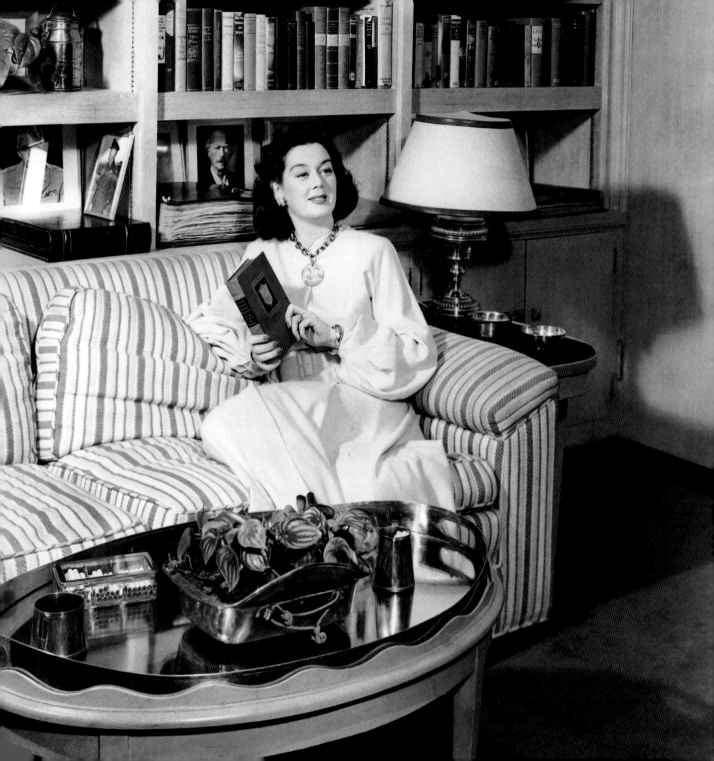

"Book-filled shelves, bleached mahogany walls and a generous fireplace lend charm and warmth to the den of **ROSALIND RUSSELL**'s home in Beverly Hills," reads the typed snipe on the back of this 1947 photo. In the four-time-Oscar-nominated actress's hands: *Good Night, Sweet Prince: The Life and Times of John Barrymore*, author Gene Fowler's affectionate bio of another celebrated thespian.

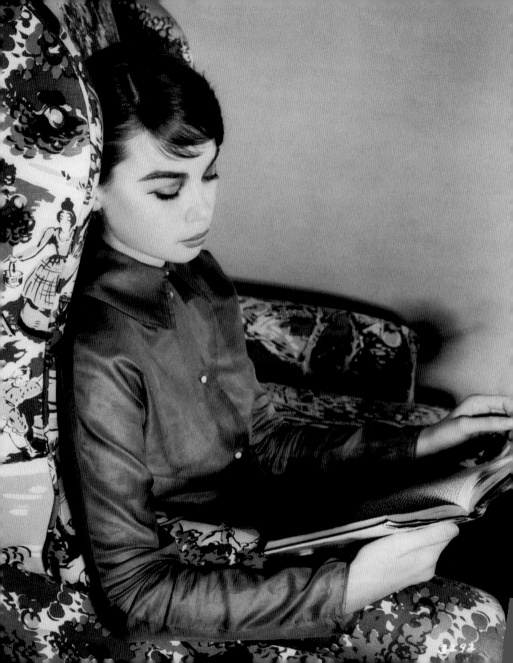

In 1955, French export **LESLIE CARON** made two films for MGM: *The Glass Slipper*, a retelling of the Cinderella tale, and *Gaby*, a loose adaptation of *Waterloo Bridge*. This gorgeous photo of Caron with a Modern Library edition of William Faulkner's *Absalom, Absalom!* on her lap was taken in Caron's Laurel Canyon home to promote one of those films. Caron's Hollywood career was launched in 1951 when she starred—and danced—opposite Gene Kelly in *An American in Paris*. Two years later she was nominated for a Best Actress Oscar for the title role in *Lili*. In 1958 another Best Actress nomination, and a Golden Globe, for *Gigi*. In 2010, Caron published a memoir, *Thank Heaven*.

ERROL FLYNN stops his library globe from spinning on "the barbarous South Sea islands" where his 1946 adventure yarn, *Showdown*, takes place. The swashbuckling star wrote three books wrote three books over his career: *Beam Ends* (1936), the account of Flynn and three sailing buddies navigating the tricky Tasman Sea, *Showdown*, a ripping high-seas yarn, and *My Wicked, Wicked Ways* (with ghost writer Earl Conrad), a memoir published posthumously in 1959. In between he made a few pictures you may have heard of: *The Adventures of Robin Hood, Captain Blood, The Dawn Patrol, The Sea Hawk*, and *They Died with Their Boots On* among them.

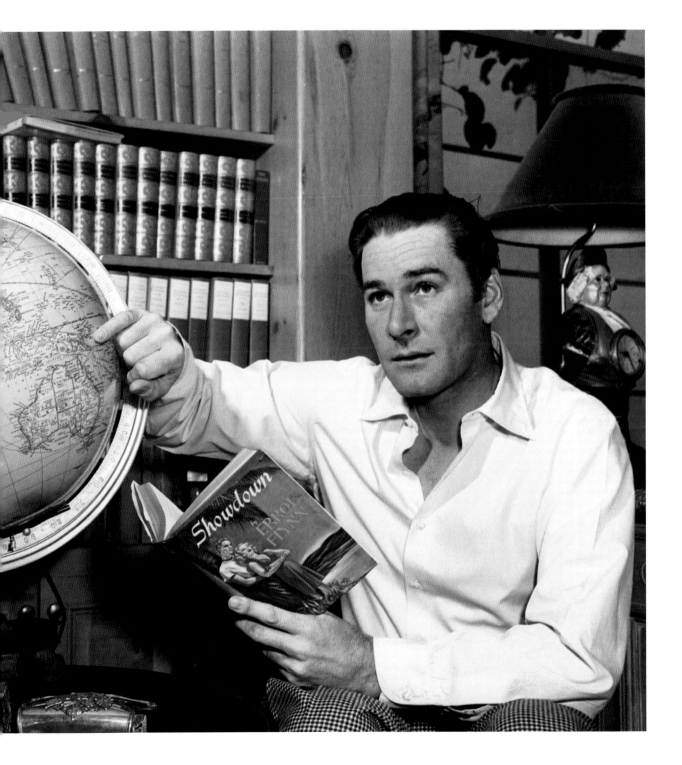

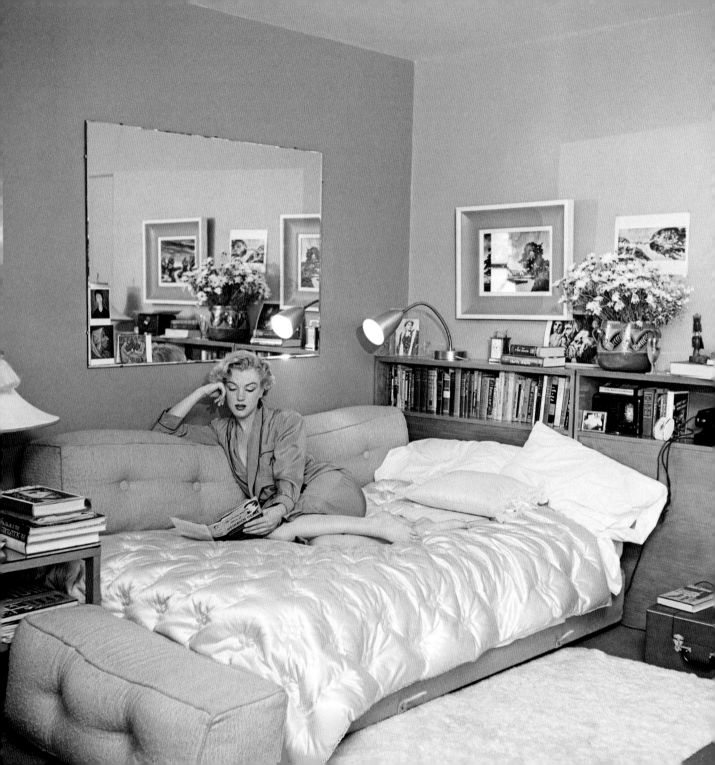

In her journey from 20th Century Fox contract player to 20th century pop culture icon, **MARILYN MONROE** made a habit of having photographers capture her with a book in hand. Be it James Joyce's *Ulysses*, or *What You Can Do for Angina Pectoris and Coronary Occlusion* (truly—that's what's she's "reading" in a 1948 bathing suit shot!), the tomes helped counter the notion that she was just another vacuous La La Land blonde. And clearly she wasn't: In 1999, Christie's auctioned over 400 books from Monroe's personal library—novels, classics, artist monographs, history, biography, you name it. And the late star's journal entries, letters, poems, and notes reveal a deeply curious soul. In this 1951 photo, Monroe is curled up on her sofa bed with a copy of *The Poetry and Prose of Heinrich Heine*, an 874-page collection of the German-Jewish lyric poet's writings in translation. And on the shelves and end tables: a Charlie Chaplin bio, Dürer and Michelangelo coffee table books, Tolstoy's *War and Peace*, Steinbeck's *Tortilla Flats*, Hemingway's *The Sun Also Rises*, Alan Barth's *The Loyalty of Free Men,* and Stanislavski's *Building a Character* (work-related). Also on a shelf: a small framed photograph of Arthur Miller, with whom she had recently commenced an affair. In 1956, the Pulitzer Prize-winning playwright and *The Seven Year Itch* sex symbol would marry.

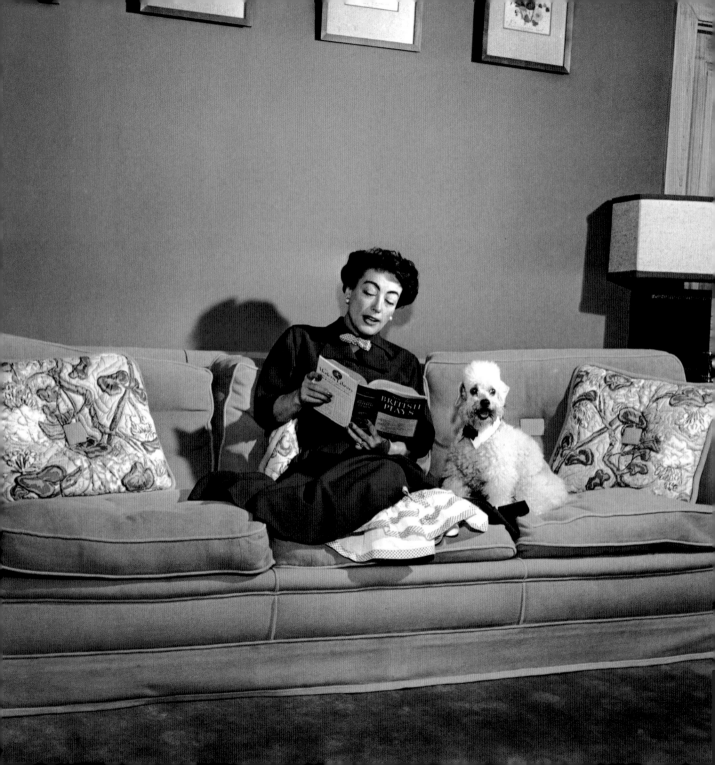

Noël Coward's *Cavalcade*? J. B. Priestley's *Dangerous Corner*? Oscar Wilde's *The Importance of Being Earnest*? **JOAN CRAWFORD** cozies up with Clicquot, her poodle, to sample some tasty morsels from the Modern Library Giant edition of *Sixteen Famous British Plays: Complete and Unabridged.* Crawford's film career spanned six decades, from the silent era to the noisy 1970 sci-fi horror spectacle *Trog.* She authored two autobiographies: *A Portrait of Joan* (1962) and *My Way of Life* (1971).

It's 1939, and **ORSON WELLES**, having already conquered stage (Broadway's *Caesar*) and radio (the alien invasion broadcast *The War of the Worlds*), has headed west to work on his first film. At his Brentwood home with a pipe and a copy of *A History of Technology, Vol. III: From the Renaissance to the Industrial Revolution*, Welles was plotting to bring Joseph Conrad's *Heart of Darkness* to the big screen. But RKO balked at the price of the ambitious project, and so Welles instead made his directing-writing-producing-and-starring-in debut with a little something he called *Citizen Kane*. Welles's *Heart of Darkness* screenplay has only ever been performed once—as a stage reading, in 2012.

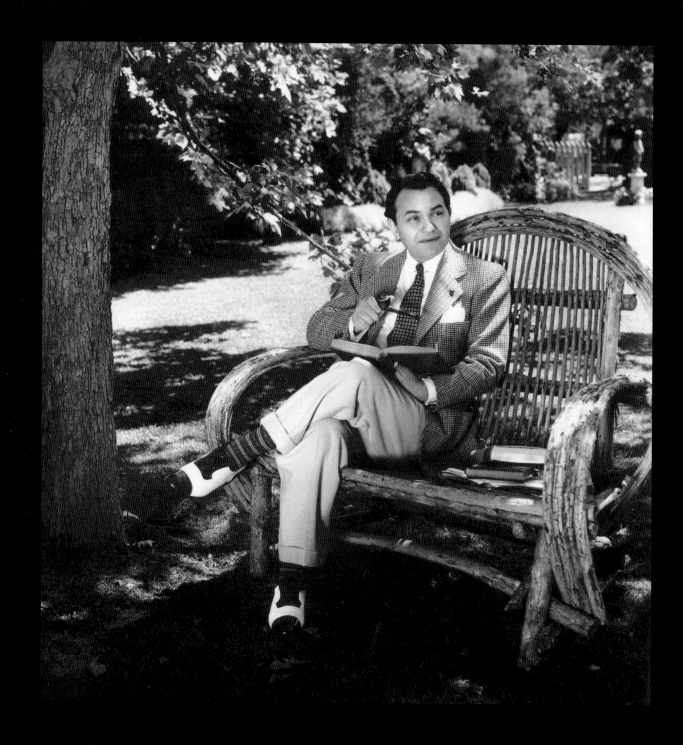

Captured in his Beverly Hills garden enjoying a satisfying pipe and volume (with a couple of backup titles stacked on that rustic twig bench), **EDWARD G. ROBINSON** had recently finished the 1936 Warner's crime drama *Bullets or Ballots* with Humphrey Bogart. (Classic Robinson line from the gangster pic: "I just want to thank you for the kick in the teeth.") Known for his collection of French Impressionist art, Robinson was also an avid reader, with a library full of first editions. His autobiography, *All My Yesterdays*, was published in 1973.

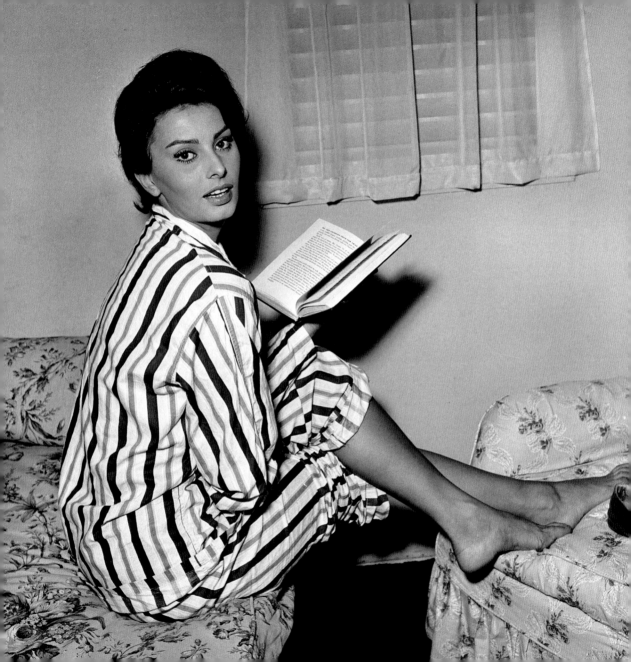

In stripy pajamas, **SOPHIA LOREN** takes to her bed—her bedtime reading, that is. The Italian actress was in London in 1956 for the production of the World War II drama *The Key*, in which she portrays a Swiss expat called upon by a succession of Royal Navy tug captains. Loren is reading *The Champion from Far Away*, a collection of short stories by Ben Hecht—the prolific scribe who just happened to have scripted *Legend of the Lost*, the lusty Sahara adventure yarn she would star in with John Wayne the following year.

In 1953, while shooting *Sabrina* at Paramount Studios, **AUDREY HEPBURN** rented an apartment in Beverly Hills—an apartment with shag carpeting, a flamingo bedspread, and a tray for her breakfast. Barefoot and be-striped, the leading lady, with the title role as a chauffeur's daughter caught between Humphrey Bogart and William Holden, posed for an at-home and on-the-job series that photographer Mark Shaw took for *Life* magazine. A caption for the piece notes, "While eating, she often reads classical drama, with heavy helpings of Shaw and Shakespeare." A few years down the line, Hepburn would play a New York bookshop clerk who falls into an affair—and into some great dance numbers—with Fred Astaire, in *Funny Face*.

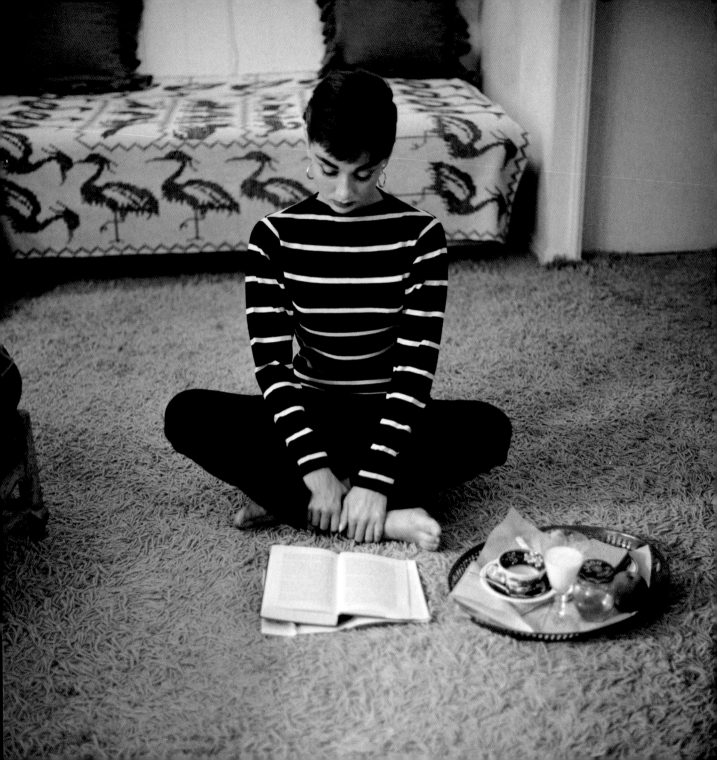

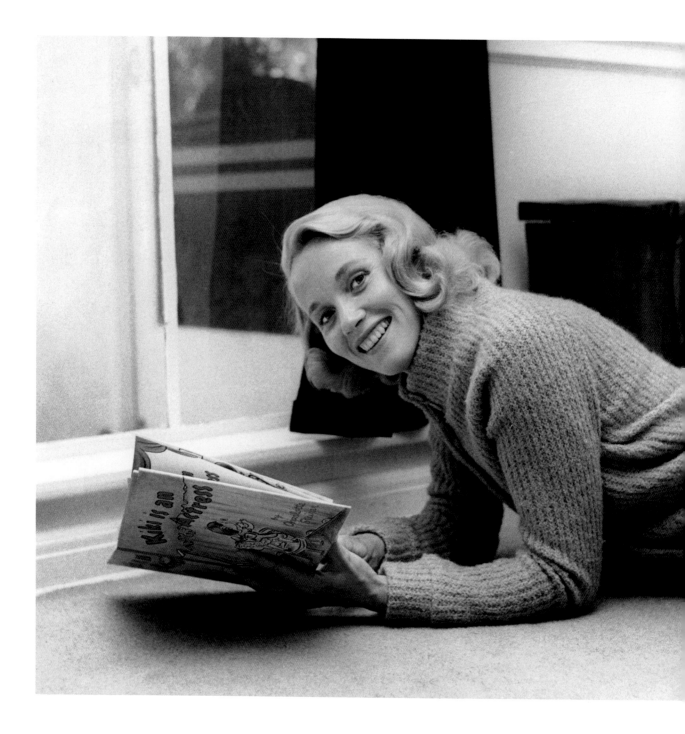

EVA MARIE SAINT lounges with a copy of Charlotte Steiner's picture book *Kiki Is An Actress*. Saint, of course, is an actress too: By the time this photo was taken in 1958, she had transitioned from roles in television in New York to making her big-screen debut opposite Marlon Brando in *On the Waterfront*. The result— a Best Supporting Actress Oscar. Key roles in *A Hatful of Rain* and *Raintree County* followed. And in 1959 she'd be scaling the presidential foreheads of Mount Rushmore with Cary Grant in Hitchcock's *North by Northwest*.

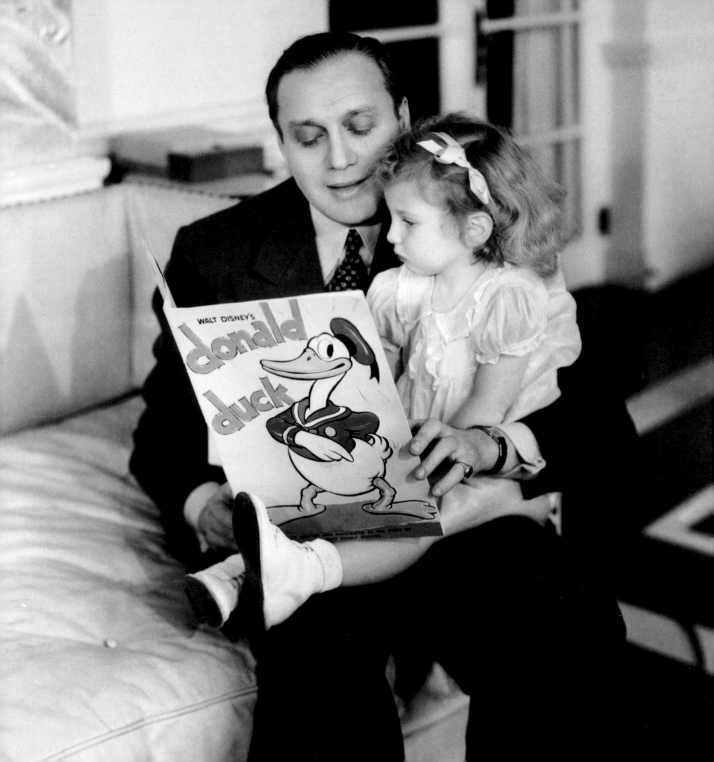

JACK BENNY, vaudevillian-turned-radio-star-turned-film-funny-man (and soon-to-be TV icon) is captured at home in a candid shot with four-year-old daughter Joan. Paramount released the publicity photo to promote its 1939 romantic comedy *Man About Town*, in which Benny courts Dorothy Lamour, and liaises with Binnie Barnes and Betty Grable, too. The 1935 heavy linen Whitman edition of *Walt Disney's Donald Duck* ("Story written and illustrated by the staff of the Walt Disney Studios."), featuring the sailor-hatted mallard and a couple of rodents by the name of Mickey and Minnie, now goes for more than $300 on antiquarian book sites and eBay. The famous spendthrift Benny would have appreciated that.

Munro Leaf's *Fair Play*—a primer about citizenship, selflessness, and getting along—is pored over by MGM star **ROBERT YOUNG** and daughters Carol Ann and Barbara in the family's San Fernando Valley home. A steady-as-he-goes screen star, Young segued to television in the late 1950s, applying his real-life parenting skills to the hit family sitcom *Father Knows Best.* A decade later, he applied his medical skills (Young had numerous physician roles, as far back as 1931) in the popular drama, *Marcus Welby, M.D.*

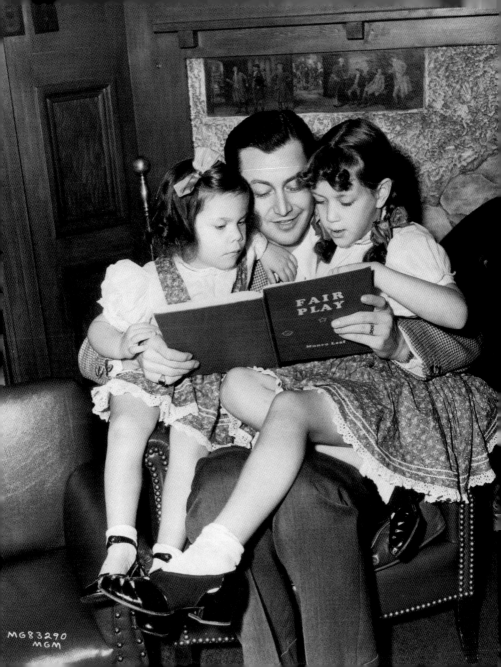

Husband and wife **JOHN CASSAVETES** and **GENA ROWLANDS**, who were both working steadily in TV in the early 1960s, study *Baby Animals*, the Garth Williams picture book, with their baby— well, toddler—Nick Cassavetes. He would follow in his parents' footsteps, acting and directing. And Cassavetes senior would direct Rowlands in nine independent, improvisational gems, including 1968's *Faces*, 1974's *A Woman Under the Influence*, and 1980's *Gloria*.

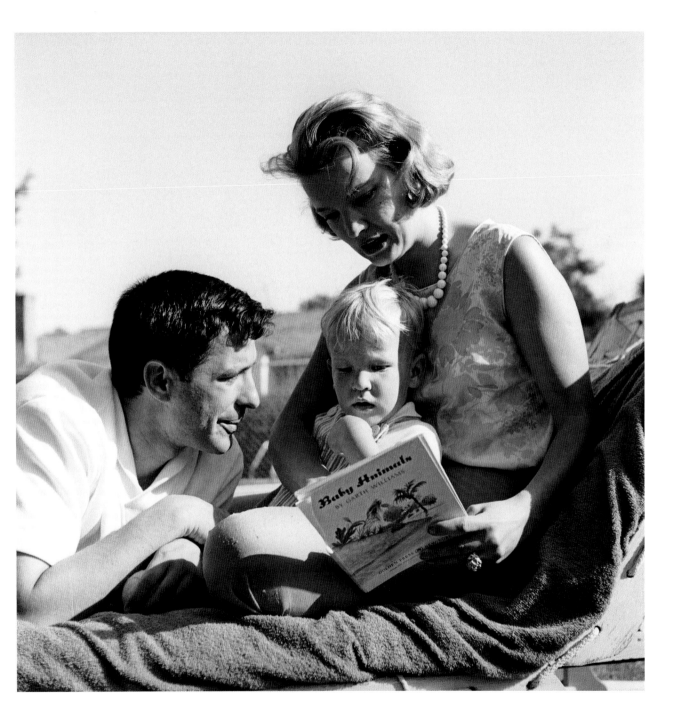

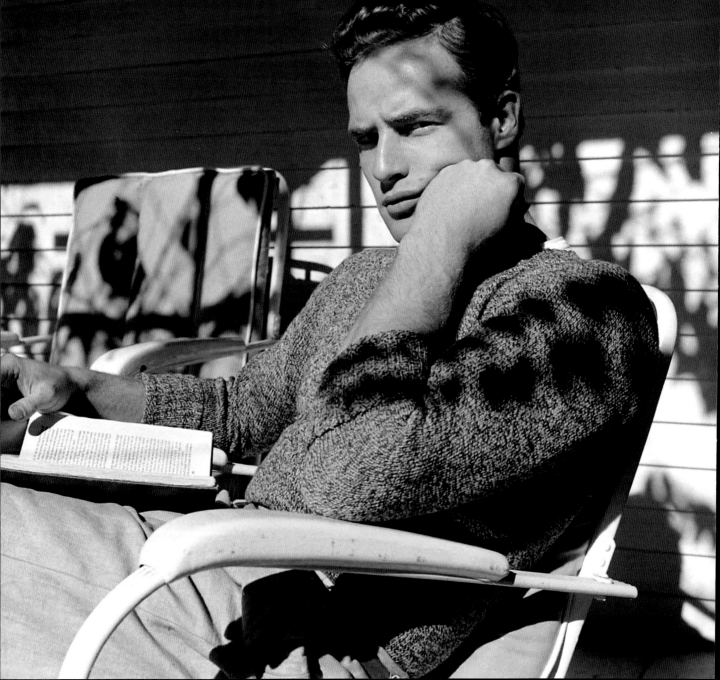

Trading his character's wheelchair for a piece of porch furniture, **MARLON BRANDO**—all of 25 years old—takes time with a book between scenes for his screen debut, the 1950 wounded vets drama, *The Men*. Fresh from the New York stage (and Stella Adler's acting classes), Brando was cast as "Bud" Wilocek, an Army lieutenant paralyzed from the waist down in World War II. Fred Zinneman's film tracks Bud's struggles to shake off a killing depression and begin life anew with the woman who loves him (played by Teresa Wright). Brando spent the month leading up to production at the Veteran's Administration hospital in Van Nuys, learning to maneuver a wheelchair, use leg braces and crutches, and befriending the paraplegics and quadriplegics in his thirty-two-bed ward. The actor's sophomore effort: *A Streetcar Named Desire*, and a Best Actor nomination. Two consecutive Best Actor nominations followed, and then, in 1955, Brando won the Academy Award for his stormy portrayal of prizefighter-turned-dockworker Terry Malloy in *On the Waterfront*.

On the set of the 1958 western *The Bravados*, the cowboy-hatted, cowboy-booted **JOAN COLLINS** is deep into Thomas Wolfe's delirious doorstop of a classic, *You Can't Go Home Again*. (This Grosset Universal Library paperback edition clocks in at 743 pages.) Beginning with *Past Imperfect*, her 1978 autobiography, the English actress would join Wolfe on library shelves. Her eighteen titles include memoirs, novels, and beauty and health books. The actress's sister, of course, was best-selling scribe Jackie Collins.

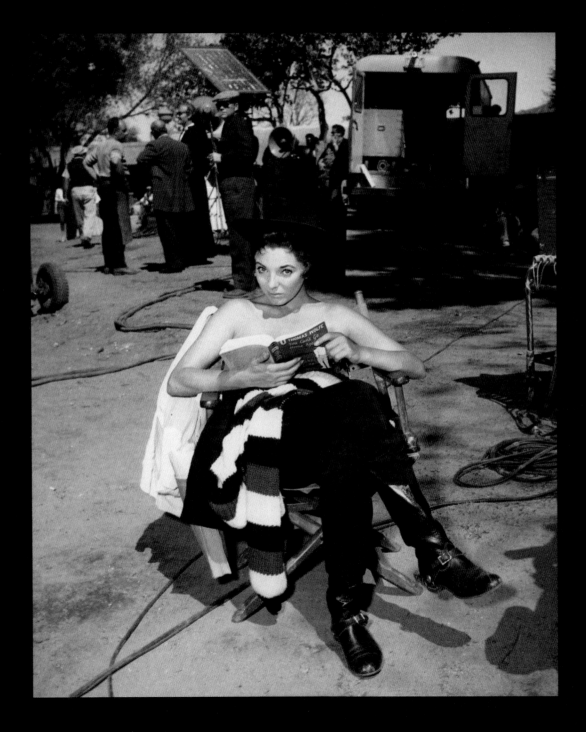

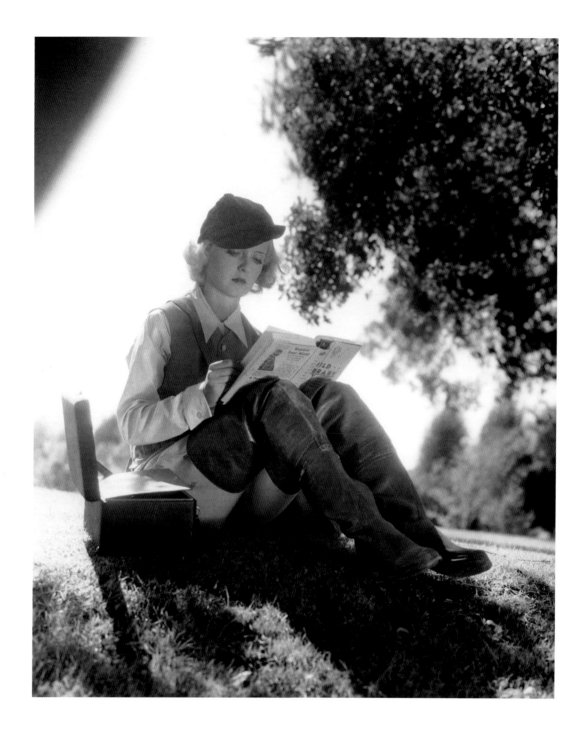

Outfitted in fashionable riding gear, Warner's star **BETTE DAVIS** keeps her reading material secret beneath a Guild Library dust jacket, the back of which features an ad for a modern-day (1930s, that is) brand of Rosicrucianism. "Explore Your Mind!" screams the invitation to try out the centuries-old spiritual business. "Discover your mental health and overcome your limitations," the Rosicrucian Brotherhood copy goes on. Ms. Davis's career spanned seven decades, with two Oscars and some of the most memorable screen performances of all time. In December 1938, the *New York Times* reported that Davis's husband, Harman "Oscar" Nelson, wanted a divorce. His complaint? Davis read too much. He "usually just sat there while his wife read 'to an unnecessary degree.'"

A flat tire on the way to work can wreck anyone's day, but **JEAN SIMMONS** seems to be taking the mishap in stride. The English actress, who would go on to garner accolades and awards in films including *Hamlet, The Robe, Guys and Dolls, Elmer Gantry,* and *Spartacus,* opens Dora Aydelotte's family saga *Run of the Stars.* Simmons, who was shooting 1947's *The Woman in the Hall* outside of London, waits for the SAG wagon immersed in the novel by the Oklahoman writer whose (slightly) better known prairie fictions include *Full Harvest* and *Trumpets Calling.*

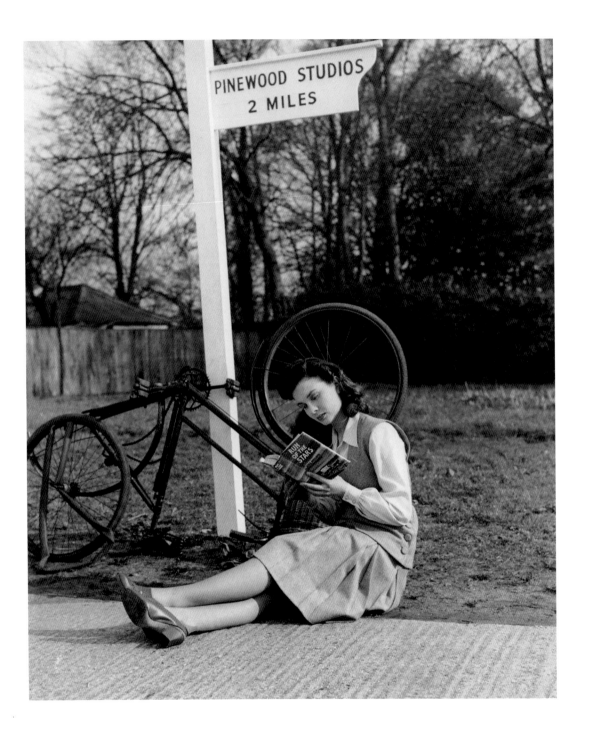

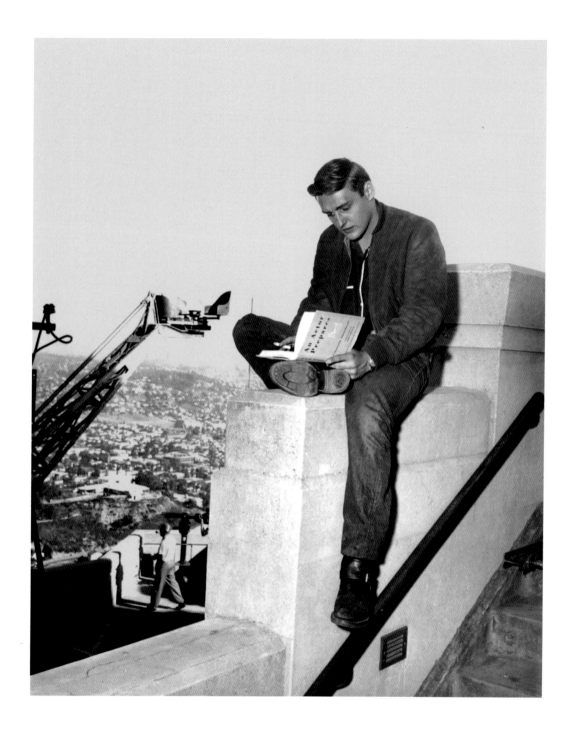

With a book that provides its own photo caption, **DENNIS HOPPER** breaks between scenes of Nicholas Ray's seminal teen angst drama, *Rebel Without a Cause*. The actor, in the early days of a career that would head well into the aughts, worked with James Dean in both 1955's *Rebel Without a Cause* and the following year's *Giant*. Perched atop a ledge at the Griffith Park Observatory, Hopper homes in on an exercise in Konstantin Stanislavsky's *An Actor Prepares*. Both Hopper and Dean were diehard practitioners of the Method, a system of acting formulated by the early twentieth century acting guru.

Jazz giant Louis "Satchmo" Armstrong's autobiography proves the perfect between-scenes reading material for **GRACE KELLY**, who stars as heiress Tracy Lord in *High Society*, the 1956 musical remake of *The Philadelphia Story*. Armstrong appears as himself in the movie, doing a swinging number with Bing Crosby, "Now You Has Jazz" (written by Cole Porter). Both Crosby and Frank Sinatra are vying—and crooning—for Kelly's affections, with Crosby winning the day, and getting to sing "True Love" in a duet with Kelly as they sail off into the sunset. And speaking of sailing off, *High Society* marked Oscar-winning Kelly's final role before quitting the biz to become Princess of Monaco.

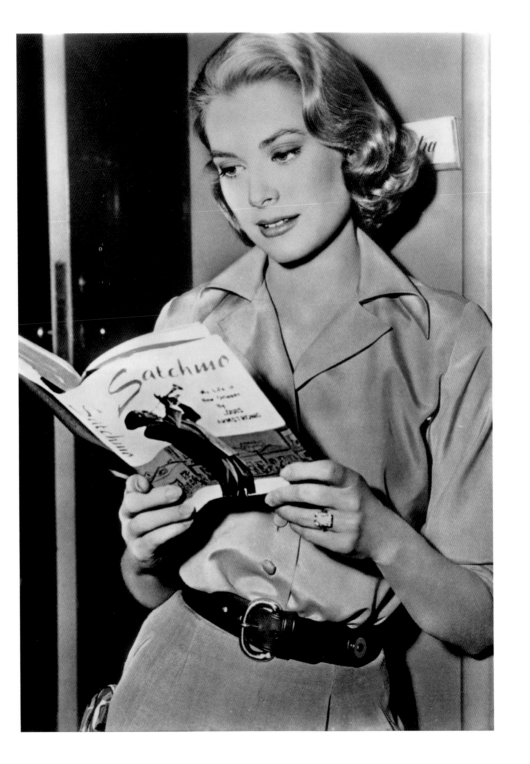

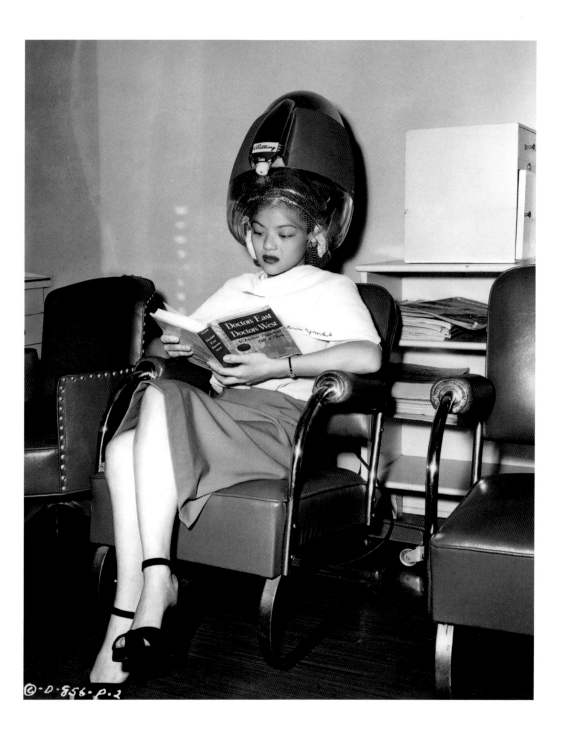

Signed to Columbia Pictures in 1947, Gloria Sui Chin of Detroit, Michigan, was given a new name—**MAYLIA**, the Cantonese word for "beautiful"—and given the role of an orphaned Chinese teen in the Dick Powell thriller *To the Ends of the Earth*. Here she reads *Doctors East Doctors West: An American Physician's Life in China* by Edward H. Hume during a coiffure fix off set. Other pics in Maylia's CV: *Boston Blackie's Chinese Adventure*, *Chinatown at Midnight*, *Call Me Mister*, and *Return to Paradise*, all made in the late 1940s and early 1950s. After leaving moviedom, the actress and her husband ran the popular chain of SoCal restaurants Ah Fong.

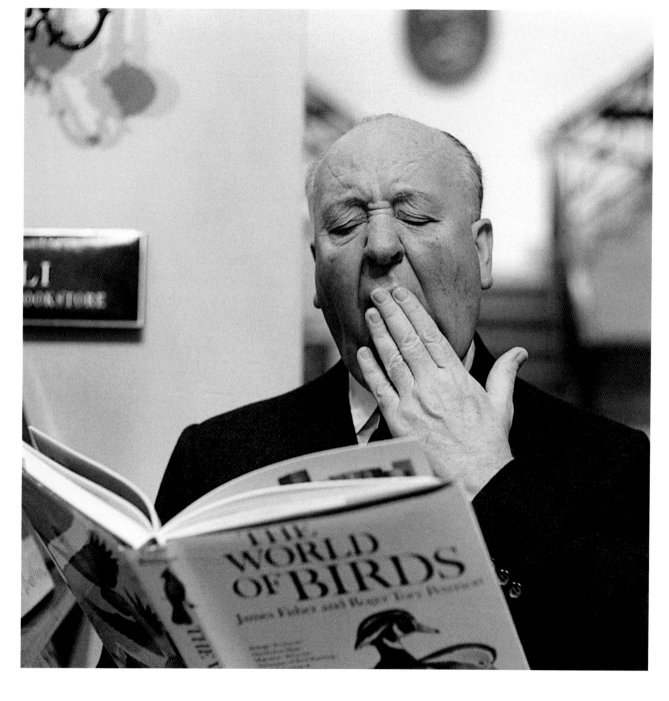

ALFRED HITCHCOCK dropped into New York's Rizzoli bookstore in early 1965, stifling a theatrical yawn as he perused the color plates of *The World of Birds*—James Fisher and Roger Tory Peterson's "comprehensive guide to general ornithology." But the magnificent coffee-table book seemed old hat for the master of suspense, whose mega-popular *The Birds*, a Technicolor scare-'em-up about menacing crows and sinister seagulls, had theatergoers screaming just two years earlier.

Nightclub singer **DOROTHY DANDRIDGE** enjoyed the biggest opening in the history of Hollywood's Mocambo club when she opened there in May 1951. She also appears to enjoy a good read or two (or forty!), in this photo from later that same year. In 1954, Dandridge, who had worked steadily, albeit often uncredited, in black-themed films and musicals) became the first black woman to receive an Academy Award nomination for Best Actress—in the title role of *Carmen Jones*.

"Know anything about rare books?" private eye Philip Marlowe asks. "You could try me," the Acme Book Shop proprietress responds. And so begins one of Hollywood's best-known bookstore scenes—three minutes of antiquarian-lit chitchat (a *Ben-Hur* 1860 third edition with a duplicated line on page 116), day-drinking (Marlowe's got a flask of "pretty good rye" in his pocket), and outdated ideas about women and eyewear. Some of the sexual innuendo in 1946's *The Big Sleep* feels creaky and embarrassing now, but **HUMPHREY BOGART**'s dogged cool carries the day, and **DOROTHY MALONE** is smart and steady opposite the Warner Bros. star. William Faulkner was one of three credited scriptwriters to try to make sense of Raymond Chandler's serpentinely plotted novel. Howard Hawks directs.

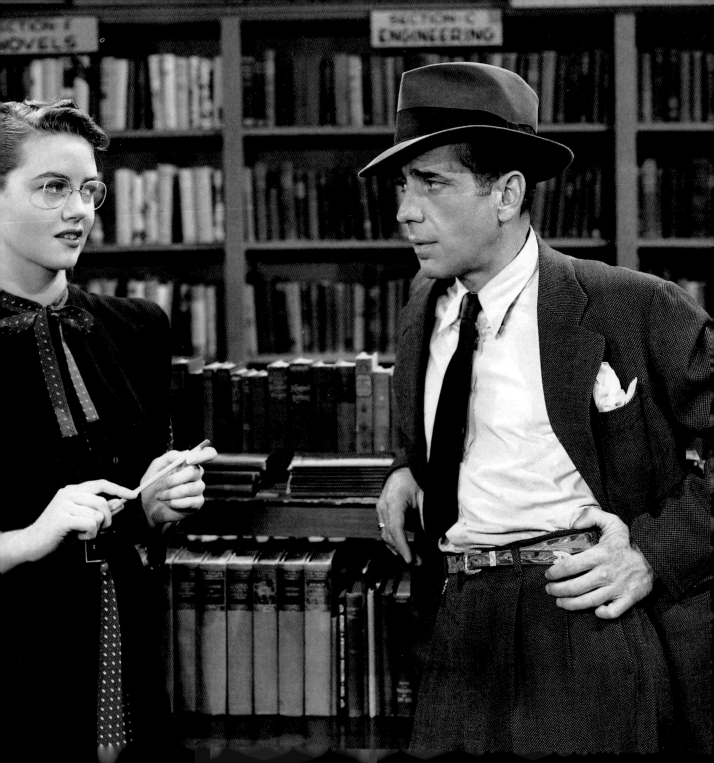

"It's all in the books," Jim Thorpe's dad tells the boy on the Sac and Fox Reservation after he's run away from school, quite literally— it's twelve miles back to the family home. Flash forward ten years in *Jim Thorpe—All American* to Carlisle Indian School, the Pennsylvania college where the Native American from Oklahoma ran track and played football, on his way to Olympic glory. **BURT LANCASTER**, who was thirty-eight when he took on the title role of the legendary athlete, evokes Thorpe's academic struggles with a furrowed brow, hunkering down over a massive dictionary. "Studying didn't come easy to Jim," goes the narration. "He often fell asleep over his books, his mind restless and troubled." Cut to the dream sequence: a montage of volumes tumbling off the library shelves onto the future gold medalist's head.

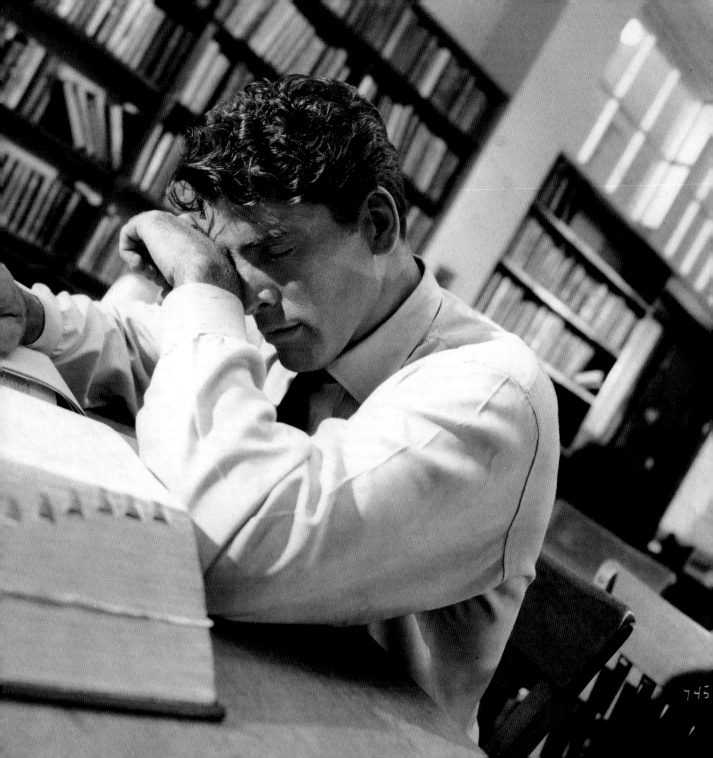

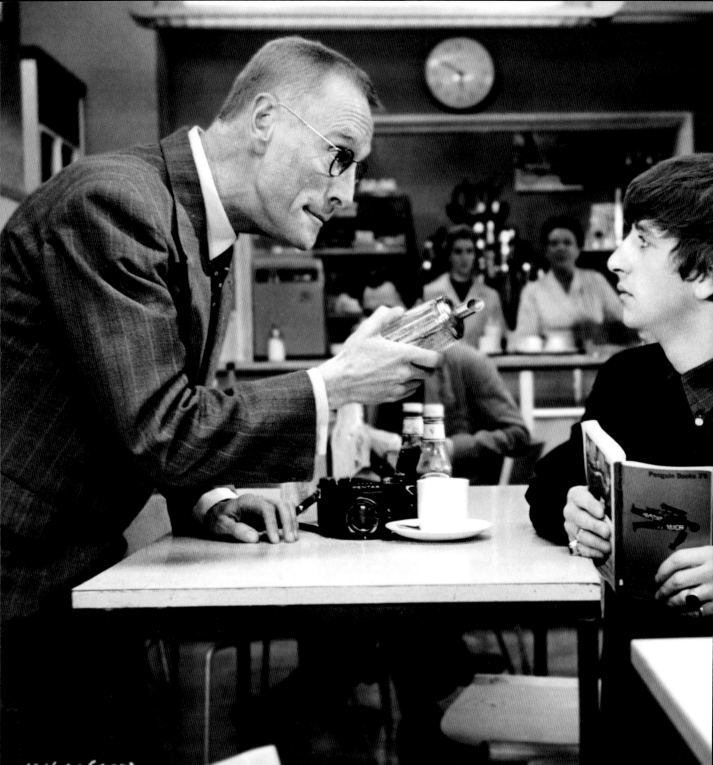

"You're tormenting your eyes with that rubbish," insists Paul McCartney's cranky granddad (**WILFRID BRAMBELL**), doing his scheming utmost to get **RINGO STARR** to give up his copy of Robert Traver's *Anatomy of a Murder* and go "parading" out in the real world. It's a pivotal scene in the 1964 Beatles hit *A Hard Day's Night*, as Ringo heads off on a moping wander, leaving his bandmates high and dry. The cover of Ringo's Penguin paperback edition boasts the same iconic Saul Bass design as the key art for Otto Preminger's Oscar-nominated film adaptation of *Anatomy of a Murder*.

HARRY BELAFONTE displays some torso and more so, posing, puffing, and perusing literature in the somewhat controversial 1957 Caribbean-set melodrama *Island in the Sun*. Adapted from the novel by the prolific Alec Waugh, the film also stars Joan Fontaine, who whiles away the days and nights in Belafonte's company, and James Mason, a plantation owner steeped in jealousy and paranoia over the assumed affair of his wife. Mason has a monologue about Dostoevsky's *Crime and Punishment,* the plot of which echoes here and there in the CinemaScope, calypso-themed pic.

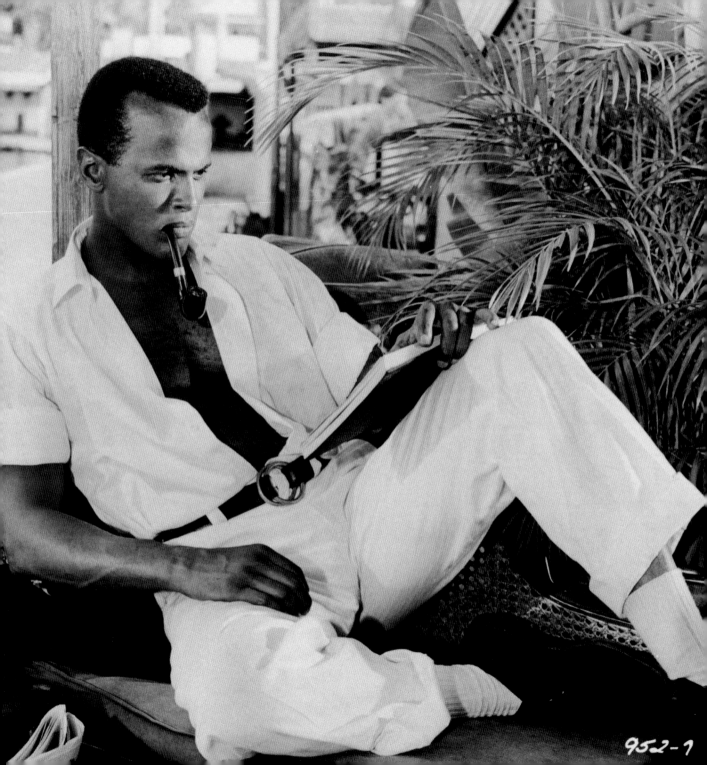

952-1

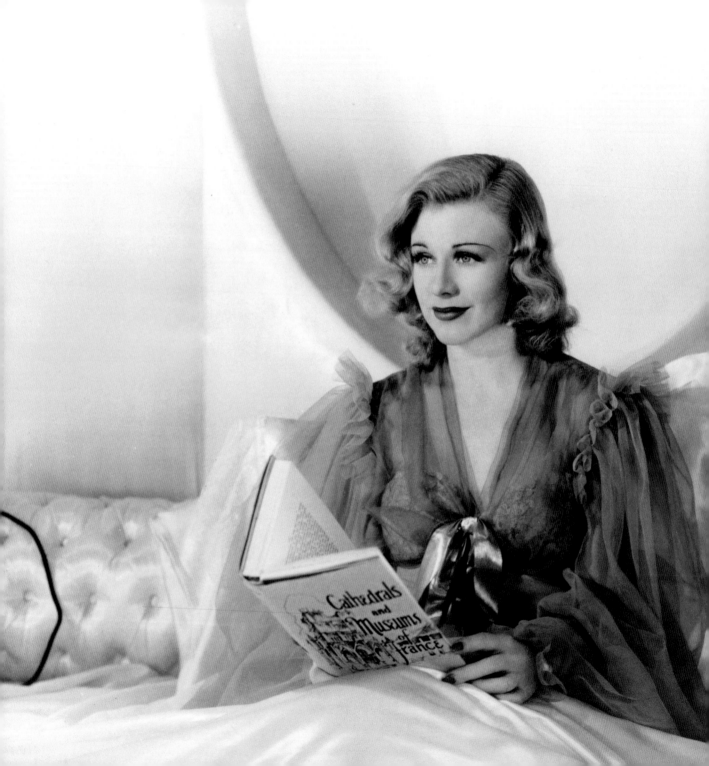

Fred Astaire's go-to dance partner, **GINGER ROGERS**, in her Irene-designed nightgown, travels through *Cathedrals and Museums of France*. In *Shall We Dance*, the 1937 Astaire-Rogers lark (with songs by George and Ira Gershwin), Rogers is a tap-dancing comedy star while Astaire has been passing himself off as a Russian ballet master. (In fact, he's from Philadelphia.) Lots of mix-ups about who's married to whom, as the RKO musical journeys from Paris to New York, with scenes—and musical numbers—aboard a luxury ocean liner, too.

"Nothing is so lovely as a sweet, fat, dimpling baby in beautiful mother's arms," reads **LANA TURNER** in 1944's pulpy *Marriage Is a Private Affair*. Turner's platinum-blonde playgirl finds herself hastily married (to John Hodiak, a U.S. Army pilot) and soon thereafter in the maternity ward, where she produces a son. In the glow of a hospital room lamp she studies *So You Have a Baby* by Lucille Nugent (a prop book), but Turner is ill-prepared for the responsibilities of parenthood. She'd rather be reading *So You Have a Date with a Guy Who's Not Your Spouse*. The film, which marked the MGM sex symbol's return to movies following her own daughter's birth, was adapted from the Judith Kelly novel—a well-received tale of a modern marriage buffeted by the stresses of war and societal change.

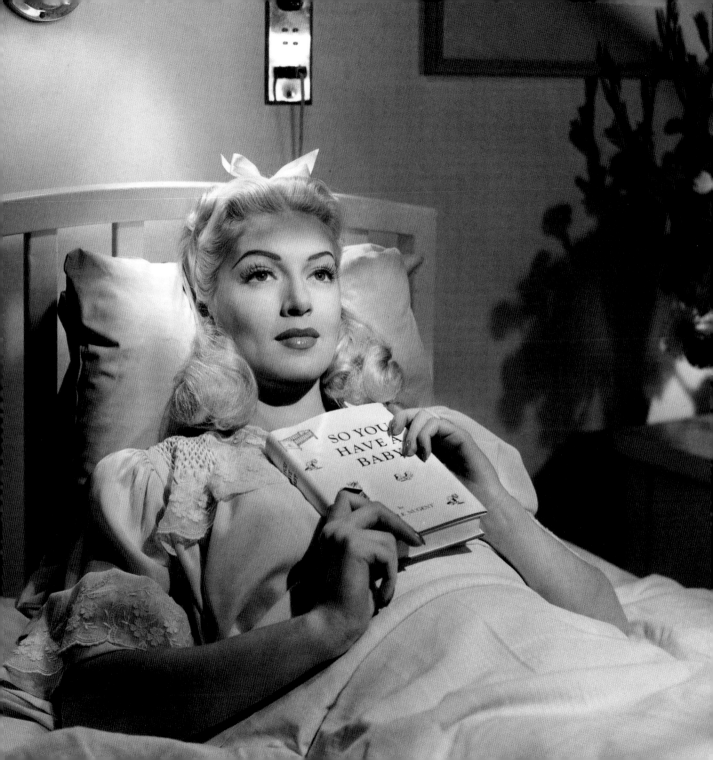

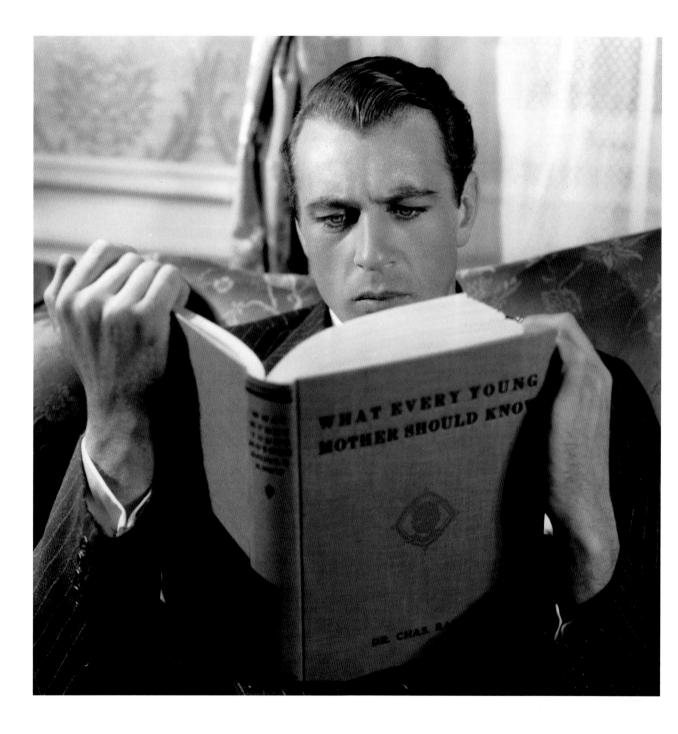

GARY COOPER takes a crash course in parenting in *Now and Forever*, a globe-hopping Depression-era yarn about a con artist widower dad, his impossibly glamorous girlfriend (the impossibly glamorous Carole Lombard), and his impossibly cute little girl (the impossibly cute Shirley Temple). Coop's newfound responsibilities of fatherhood are at odds with his character's need to hustle marks and suckers, but the triumvirate of stars—Cooper! Lombard! Six-year-old Temple!—works everything out in Henry Hathaway's 1933 hit. And *What Every Young Mother Should Know* was not a product of the Paramount Props Department: The title shows up in the bibliography of the 1910 child-rearing manual *Simple Lessons on the Physical Care of the Baby*.

GREER GARSON, as the first female teacher at a small private school for boys in 1954's *Her Twelve Men*, makes sure young **REX THOMPSON** is up on the travels and travails of Odysseus, his escape from Calypso, and all that Greek gods business. Garson, the British actress who won an Oscar for *Mrs. Miniver*, has to deal not only with her dozen Oaks School lads but also with the amorous entreaties of Robert Ryan and Barry Sullivan, too. The film, marketed by MGM as a kind of distaff *Goodbye, Mr. Chips*, was based on a story from the *Ladies' Home Journal*. (Its original title: *Miss Baker's Dozen*—ouch!) The well-worn copy of Homer's epic poem in Thompson's hands is the reliable S. H. Butcher and A. Lang translation—book number 167 in the Modern Library collection.

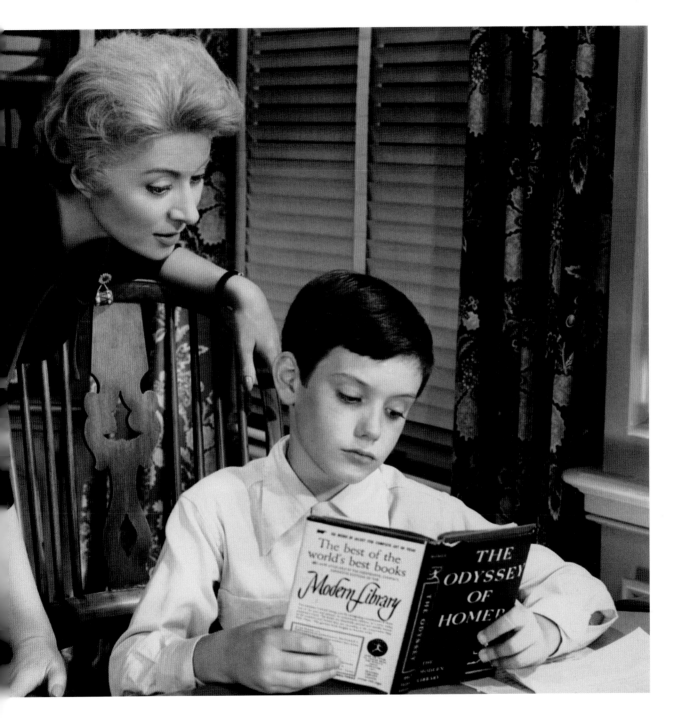

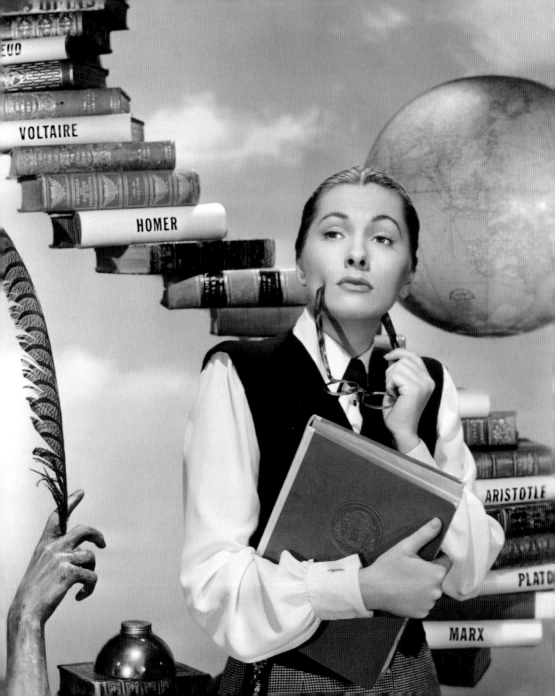

JOAN FONTAINE poses with a towering spire of Great Works—Aristotle! Freud! Homer! Marx! Plato! Voltaire!—in an aptly nutty publicity still from the screwball romance *The Affairs of Susan*. Typically remembered for serious melodramas, classic adaptations, and psychological thrillers like *Rebecca*, *Jane Eyre*, and *Suspicion*, Fontaine shines as the unconventional Susan Darell, an innkeeper's daughter who becomes a Broadway star. A trio of Susan's still-love-struck exes meets with her new fiancé in the 1945 farce to share stories of the woman they knew—and each, it turns out, has a completely different take on Fontaine's freewheeling character. Here the actress is in her bookish incarnation, sporting reading glasses and paraphrasing Hegel when she notes that "external appearance has no bearing on internal harmony." Earlier in the film Fontaine can be spotted reading Dale Carnegie's *How to Win Friends and Influence People*.

In the 1946 rom-com *Without Reservations*, **CLAUDETTE COLBERT** is a best-selling author—under the *nom de plume* Christopher Madden. On a Los Angeles-bound train she meets a Marine captain played by **JOHN WAYNE**. He doesn't think much of this writer guy Madden, but "Kit" tries to convince him otherwise, perched atop a sleeping car's upper berth reading from the soon-to-be-Hollywoodized *Here Is Tomorrow*. Love and literary criticism ensue.

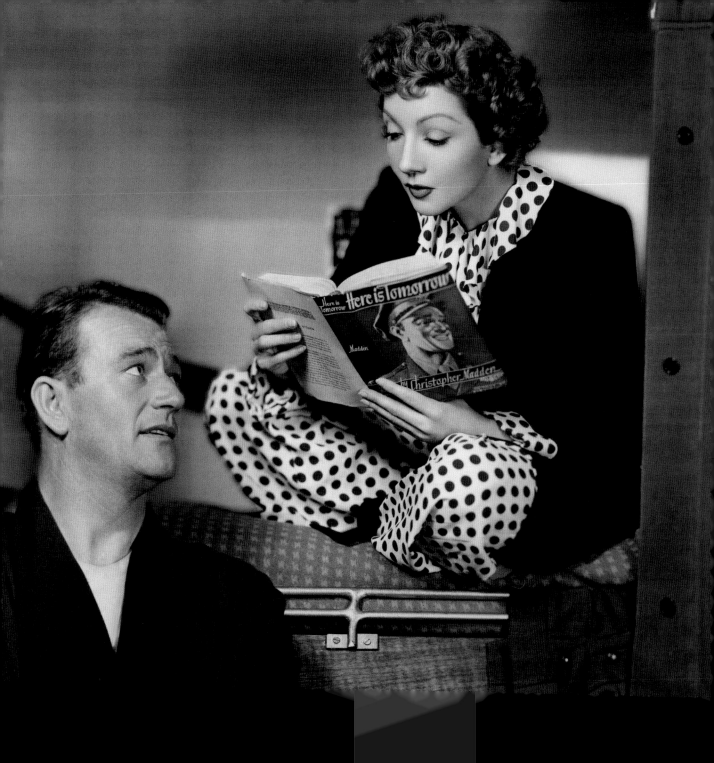

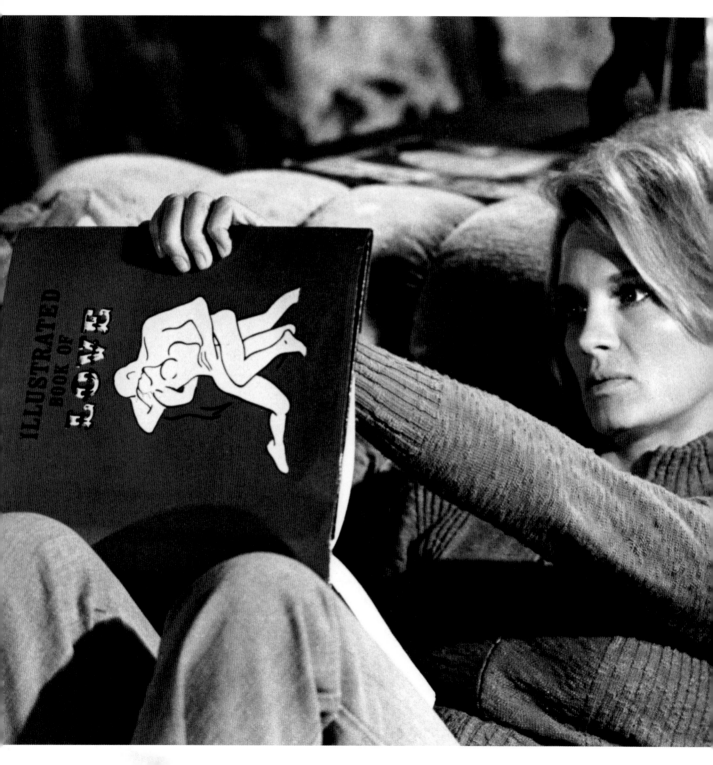

ANGIE DICKINSON reclines with *Illustrated Book of Love*, a (prop) pictorial full of sexual positions, in a scene from Roger Vadim's 1971 serial-killer sex comedy *Pretty Maids All in a Row*. Though Quentin Tarantino put the movie on his list of Top 12 all-time favorites, the MGM release is a pretty cheesy affair, with Rock Hudson as a lecherous and murderous high school coach and Dickinson—an actress with screen credits that include *Ocean's 11, Rio Bravo, Point Blank,* and *The Killers*—playing a libidinous substitute teacher who seduces a shy and bumbling student. Vadim originally wanted Brigitte Bardot for the role. Dickinson holds her copy of *Illustrated Book of Love* every which way to better appreciate what the pages' coupling couple is up to.

Literary references abound in *Road to Morocco*, the third of the hugely successful **BOB HOPE**/Bing Crosby *Road to...* comedies. Even before the 1942 Paramount pic's opening title song is sung, the collected works of Shakespeare, Persian poet Omar Khayyam, and Webster's Dictionary have been cited. By the time Hope's "Turkey" Jackson has cozied up to Princess Shalmar of Karameesh (*Road to...* muse Dorothy Lamour, of course), he's in a state of shock and awe over a copy of *How to Make Love—Six Lessons from Madame La Zonga*. For the publicity still, however, the provocative prop tome was replaced with a real publication: *Power of Will*, the 1921 self-helper by Frank Channing Haddock, marketed as "a practical companion book for the unfoldment of the powers of mind."

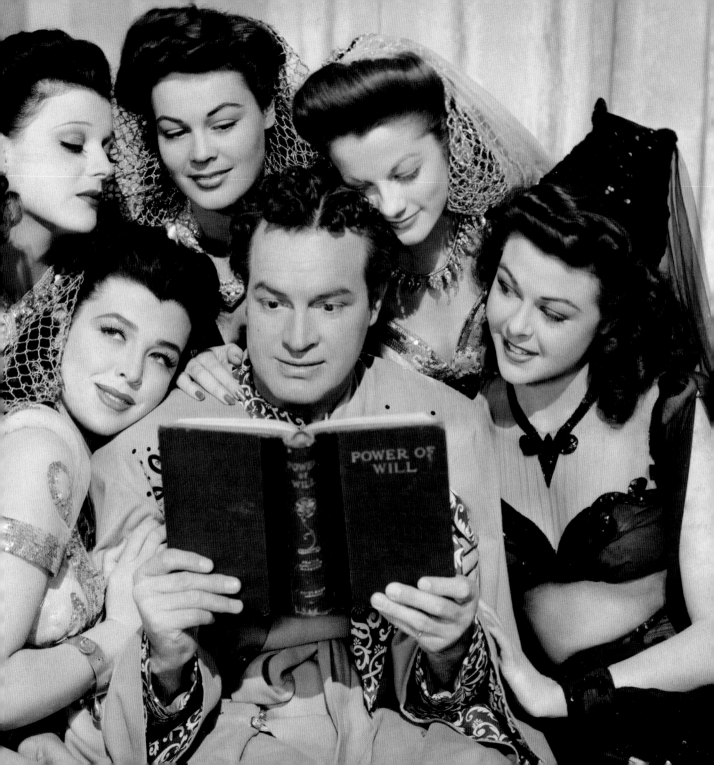

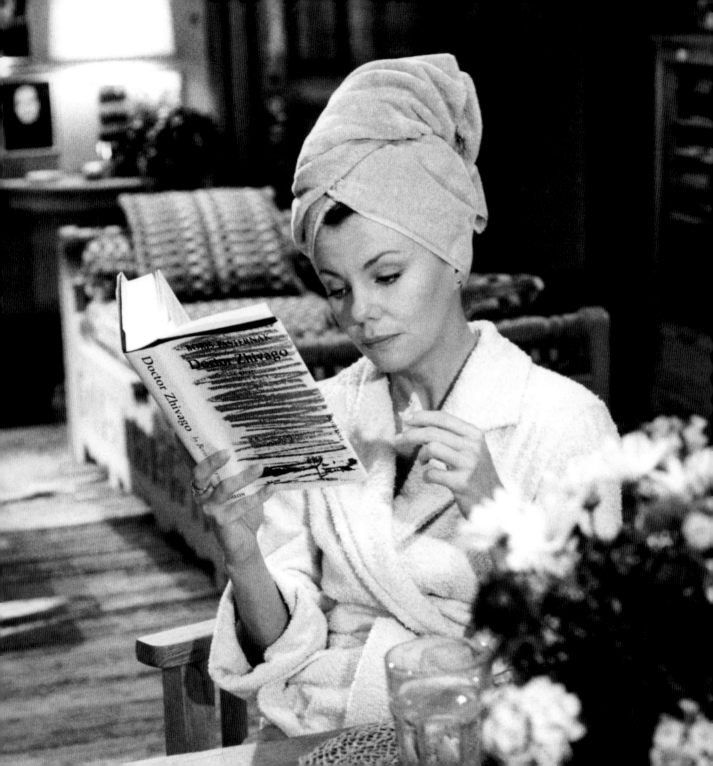

"I never realized I had so many books I never read," says **MARSHA MASON** in Neil Simon's *Chapter Two*, surveying the shelves in her apartment. "Hey, *Doctor Zhivago*—we'll try it one more time," she adds, reaching for her hardcover of Boris Pasternak's heavyweight Russian Revolution romance. Mason's character, a divorcée and actress, runs into James Caan's—a widower and writer—and their courtship begins with a series of snappy phone calls. Later, Mason can be seen reading *Queen of Zanzibar*, a spy novel by "Kenneth Blakey-Hill"—a Brit-sounding pseudonym for Caan's George Schneider.

Luxuriating in an epic bubble bath with a copy of Grace Metalious's suitably soapy *Peyton Place*, platinum-blonde **JAYNE MANSFIELD** stars as platinum-blonde actress Rita Marlowe in the 1957 comedy *Will Success Spoil Rock Hunter?* She's being courted by an ad agency to spokesmodel their "Stay-Put" lipstick, but between chapters of Metalious's bestseller (published just a year earlier, and soon to be a movie and then a TV series) Rita is more concerned about the men in her life and the nature of true love. Tony Randall, as a mid-level *Mad Men*-esque exec, is the titular hero. **JOAN BLONDELL**, tub-side, is Rita's personal assistant. A standard poodle emerges from the bath along with Mansfield—the dog and the sex symbol wrapped in matching towels.

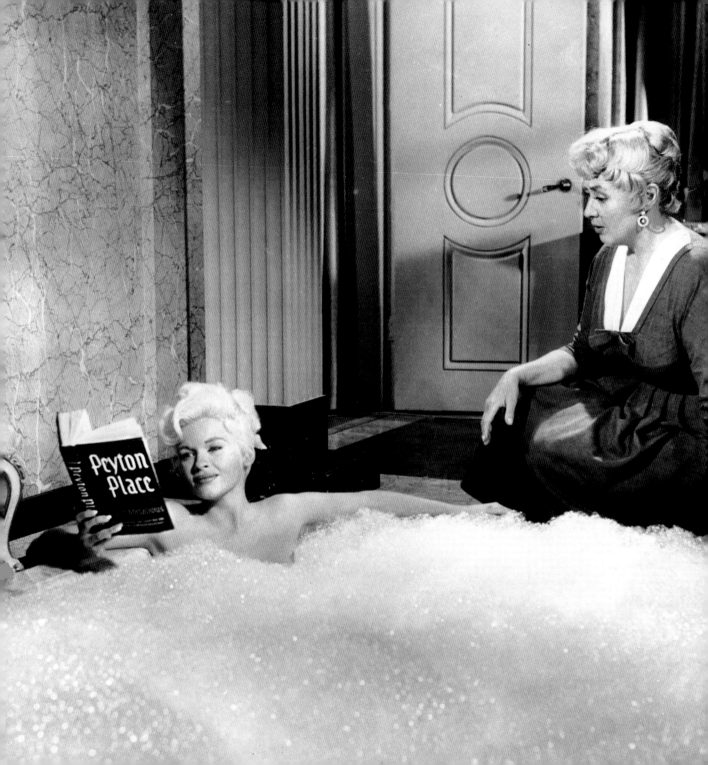

The gowns in the all-star 1962 comedy *What a Way to Go!* are by Edith Head, and maybe the legendary Hollywood designer conjured up **SHIRLEY MACLAINE**'s lacy two-piece swimsuit as well. In a role originally conceived for Marilyn Monroe, MacLaine is a distraught four-time widow with a $200-million-plus bank account and the belief that she's cursed—that she's somehow caused the deaths of her husbands, played, respectively, by Dick Van Dyke, Paul Newman, Robert Mitchum, and Gene Kelly. As for the copy of *The Agony and the Ecstasy*, 20th Century Fox wanted to plug its upcoming adaptation of Irving Stone's Michelangelo novel. Product placement, poolside.

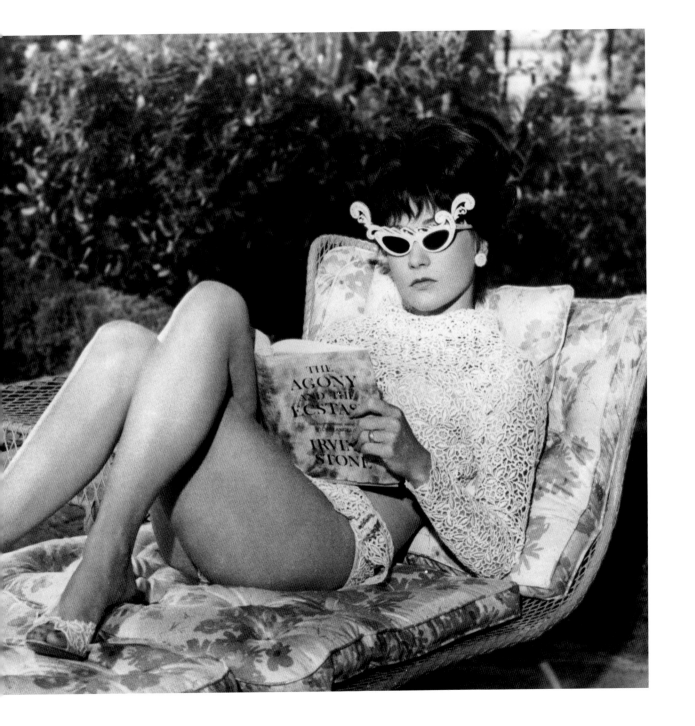

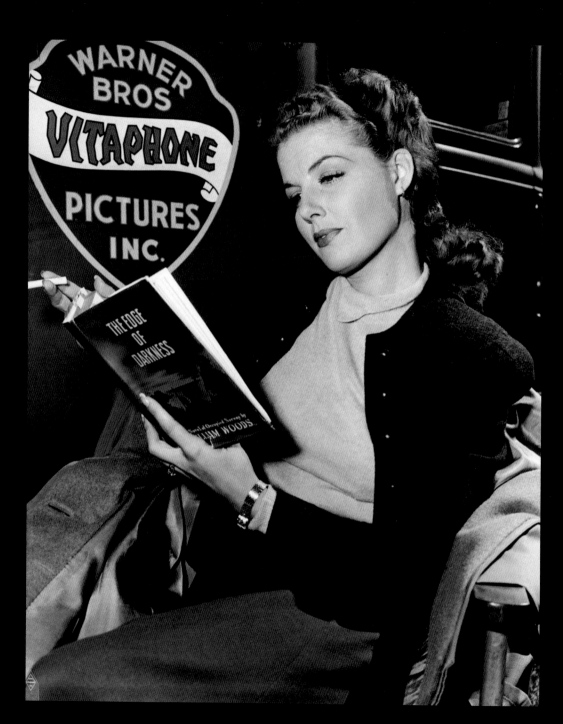

ANN SHERIDAN considers her source material on a break from shooting the World War II saga *The Edge of Darkness*, set in Nazi-occupied Norway. William Woods wrote the novel, published in 1942. The next year saw the film's release. Sheridan shares top billing with Errol Flynn. He's a fisherman-turned-underground-leader; she's a doctor's daughter who joins the fight alongside her leading man. *Kirkus Reviews* cited Woods's book as having "the ring of truth. The movie has the ring of Hollywood, but its villagers-turned-guerrilla-fighters plot is nevertheless stirring stuff." Sheridan, who can count *Angels with Dirty Faces*, *Kings Row*, and *I Was a Male War Bride* among her one-hundred-plus screen credits, was also the protagonist of a novel: In 1943 Whitman Publishing issued *Ann Sheridan and the Sign of the Sphinx*, in which the famous actress sleuths around, helping to hunt down a missing friend.

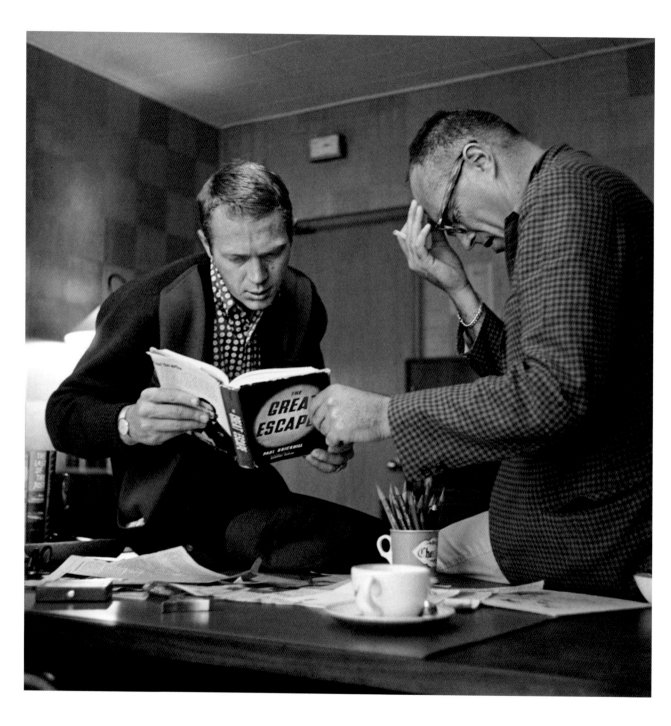

"I'm telling you, there's a motorcycle chase in here somewhere," **STEVE MCQUEEN** may have insisted to director **JOHN STURGES** as the actor and the filmmaker pore over *The Great Escape*, Paul Brickhill's bestselling account of the British and American POW breakout from Nazi prison Stalag Luft III. McQueen stars as "The Cooler King," a hotshot American pilot, in the 1963 blockbuster. Also on the desk in Sturges's office: *By Love Possessed*, James Gould Cozzens's book—another of the director's screen adaptees.

Dressed as Roderick Usher, the singularly loony lone surviving male member of the Usher clan, **VINCENT PRICE** settles back with a copy of *The Portable Poe* to bone up on his *House of Usher* role, and perhaps do some early research on the subsequent six Poe adaptations he would make with B-movie maestro Roger Corman. The trailer for the doom-y 1960 release hailed its star as "the screen's foremost delineator of the Draculean," and Price's delivery of lines like "Did you know I could hear the scratching of her fingernails on the casket lid" (re: his sister, whom he has buried alive) bears the claim out. The line readings are, well, Priceless.

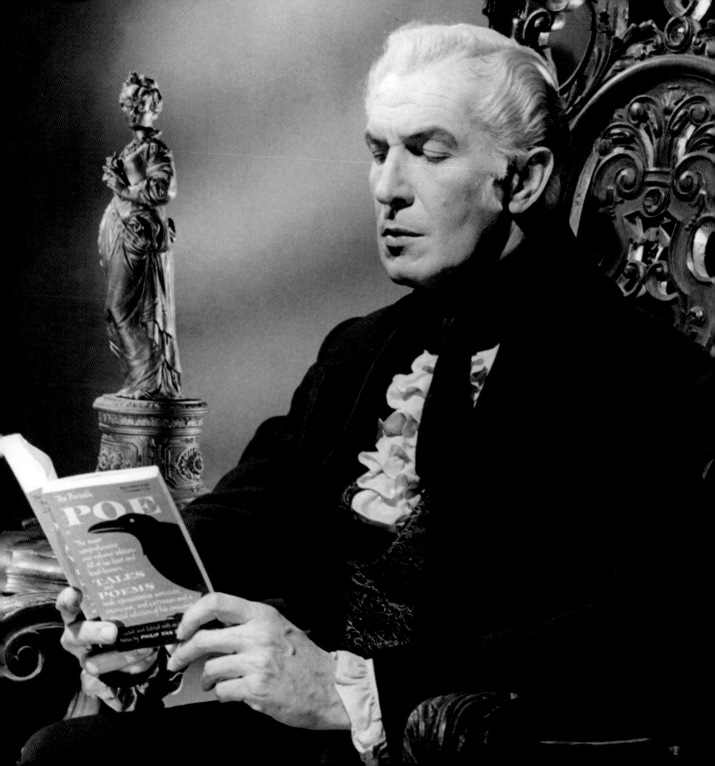

With a suitably weathered visage, veteran leading man **SPENCER TRACY** takes a moment to study Ernest Hemingway's *The Old Man and the Sea*, and to study the primitive wooden carving coincidentally laid out before him. Tracy was nominated for a Best Actor Oscar in 1959 for his portrayal of the nameless old fisherman and his epic battle with a mighty marlin.

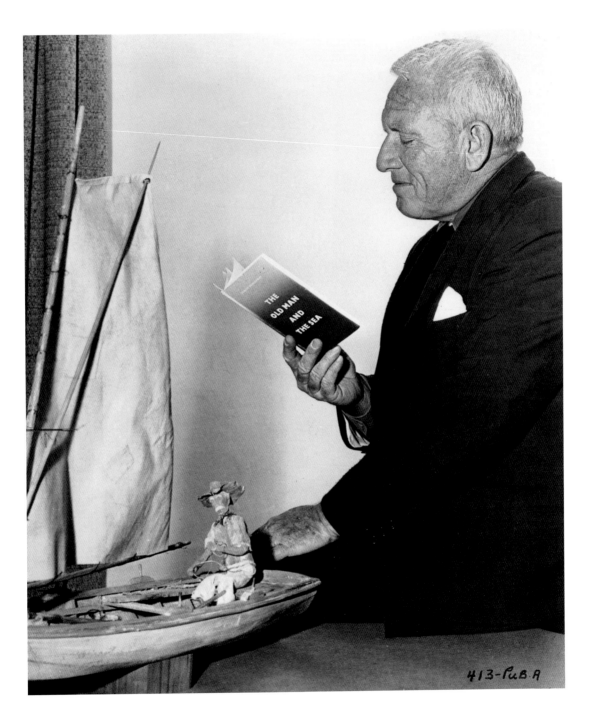

413-PuB.A

GREGORY PECK's 1960 J.P. Lippincott & Co. edition of Harper Lee's classic may or may not be open to chapter 15, where the author describes the "graying black hair and square-cut features" of her hero, the small-town Southern lawyer and dad Atticus Finch. Peck, tall and wearing glasses just like Finch, fits the role to a T. In Decemberof 1962, when Robert Mulligan's screen adaptation opened in theaters, a paperback movie tie-in hit bookstore shelves. Peck and child actress Mary Badham, who plays Atticus's wide-eyed daughter Scout, adorn the cover. Peck went on to win the Academy Award for Best Actor the following April.

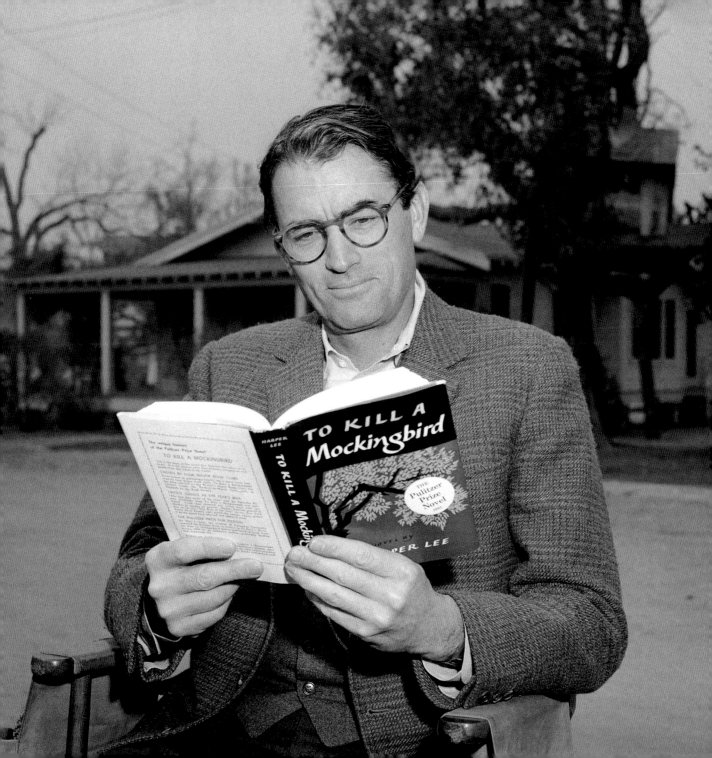

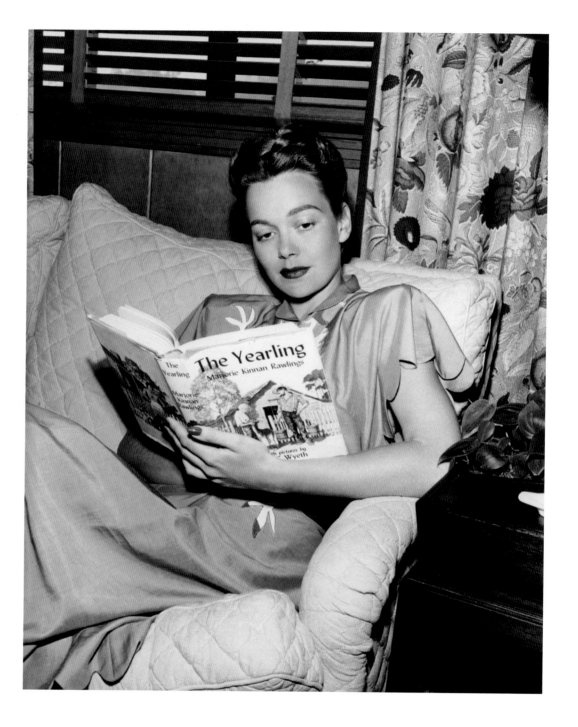

Marjorie Kinnan Rawlings's 1938 novel about a boy and his fawn in Florida scrub country was a huge seller, a Pulitzer Prize winner, and a movie, too. **JANE WYMAN** plays the lad's hardscrabble mother, Ora, in the 1946 MGM adaptation. Here she is at the end of a day's shoot doing her homework, checking out the N. C. Wyeth illustrations in the Charles Scribner and Sons original edition. Both Wyman and Gregory Peck, who stars as the boy's father, were nominated for Oscars. Rawlings was edited at Scribner by Maxwell Perkins, whose stable of authors included Hemingway, Fitzgerald, and Thomas Wolfe.

Talk about large print editions! The cast of one of the most iconic movies of all time—1939's *The Wizard of Oz*—perches atop a humongous copy of L. Frank Baum's classic tale of a Kansas farm girl and her journey to a magical, mystical, flying-monkeys-plagued land. Probably not a coincidence that the cover art for the giant-sized volume features **JUDY GARLAND** as Dorothy alongside costars Tin Man **JACK HALEY**, Scarecrow **RAY BOLGER**, Toto **TERRY THE TERRIER**, Wizard **FRANK MORGAN**, and Cowardly Lion **BERT LAHR**.

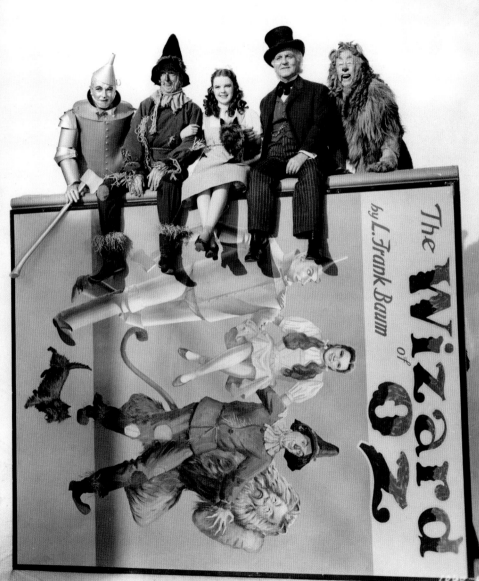

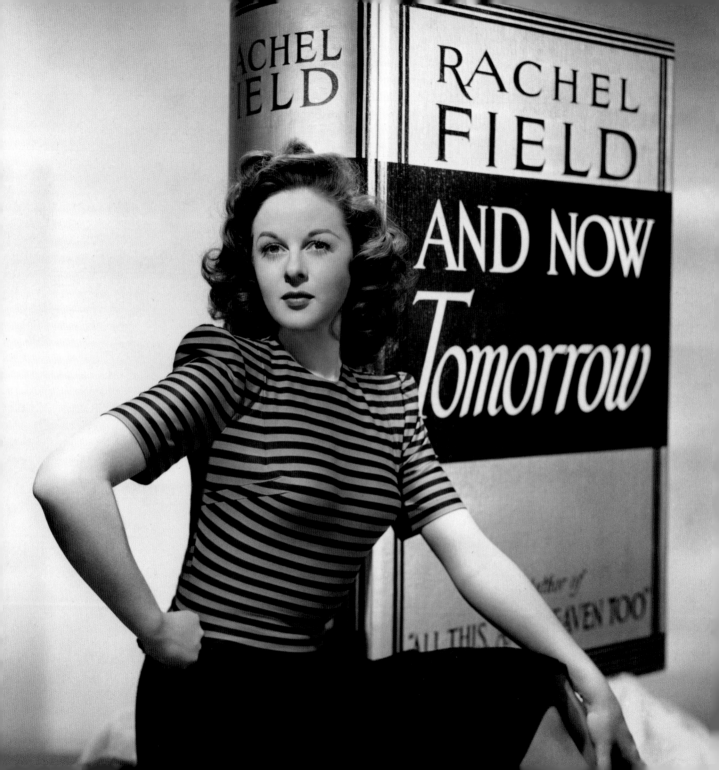

The literary pedigree of 1944's *And Now Tomorrow* is pretty impressive—**SUSAN HAYWARD** looks impressed, anyway. First, there's Rachel Field's novel, an enormous bestseller from the author of *All This, and Heaven Too*. Field won both a National Book Award and a Newbery (for her children's book, *Hitty: Her First Hundred Years*). Then there's the screenplay adaptation for the Alan Ladd/Loretta Young/Susan Hayward melodrama about a doctor's efforts to cure deafness. *And Now Tomorrow* was scripted by Raymond Chandler—one of only four produced screenplays the creator of Philip Marlowe banged out while working for Paramount in the 1940s. Hayward, who died of a brain tumor at age fifty-seven, was the subject of a multitude of biographies: *A Star, Is a Star, Is a Star! The Lives and Loves of Susan Hayward*; *Red: The Tempestuous Life of Susan Hayward*; *Susan Hayward: An Actress of Infinite Variety, the Divine Bitch*; *Susan Hayward: Her Films and Life*, and *Susan Hayward: Portrait of a Survivor*. Phew!

Three Ziegfeld Follies Girls try a different way to absorb their literature—with a well-balanced selection of tomes from the MGM library. **MARY JANE HALSEY**, **DIANA COOK**, and **EDNA CALLAHAN** all appeared in the 1930s' song-and-dance spectaculars *The Merry Widow*, *Gold Diggers of 1933*, and *The Great Ziegfeld*. Halsey also had a turn in 1942's *Cat People*, Val Lewton's spooky noir.

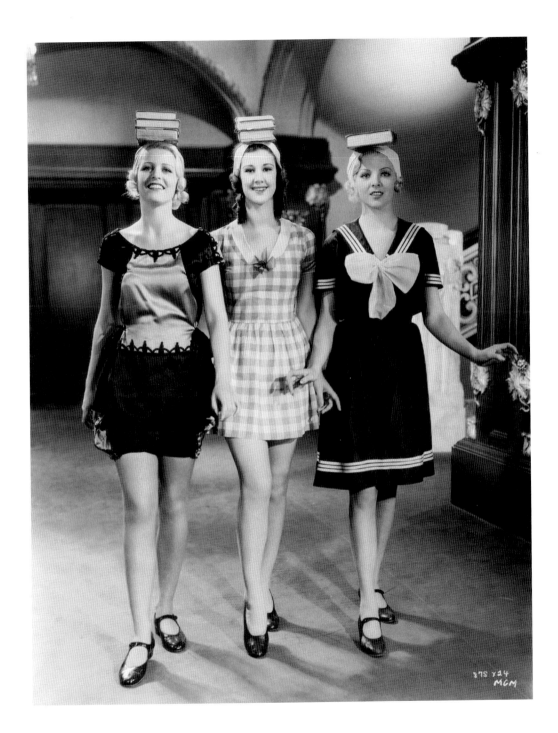

FEATURED TITLES

Absalom, Absalom! by William Faulkner

An Actor Prepares by Konstantin Stanislavsky

Anatomy of a Murder by Robert Travers

And Now Tomorrow by Rachel Field

The Agony and the Ecstasy by Irving Stone

Baby Animals by Garth Williams

Ben-Hur: A Tale of the Christ by Lew Wallace

Cathedrals and Museums of France

The Champion of Far and Away by Ben Hecht

The Complete Poetical Works of James Whitcomb Riley

Doctors East Doctors West by Edward H. Hume

Dr. Zhivago by Boris Pasternak

The Dud Avocado by Elaine Dundy

The Edge of Darkness by William Woods

Fair Play by Munro Leaf

Good Night, Sweet Prince: The Life and Times of John Barrymore by Gene Fowler

The Great Escape by Paul Brickhill

A History of Technology, Vol. III: From the Renaissance to the Industrial Revolution

Kiki Is an Actress by Charlotte Steiner

The Odyssey of Homer

The Old Man and the Sea by Ernest Hemingway

Peyton Place by Grace Metalious

The Poetry and Prose of Heinrich Heine

The Portable Poe

Power of Will by Frank Channing Haddock

The Robe by Lloyd C. Douglas

Run of the Stars by Dora Aydelotte

Satchmo: My Life in New Orleans by Louis Armstrong

Showdown by Errol Flynn

Sixteen Famous British Plays

To Kill a Mockingbird by Harper Lee

Walt Disney's Donald Duck

What Every Young Mother Should Know

The Wizard of Oz by L. Frank Baum

The World of Birds by James Fisher and Roger Tory Peterson

The Yearling by Marjorie Kinnan Rawlings

You Can't Go Home Again by Thomas Wolfe